NELLY

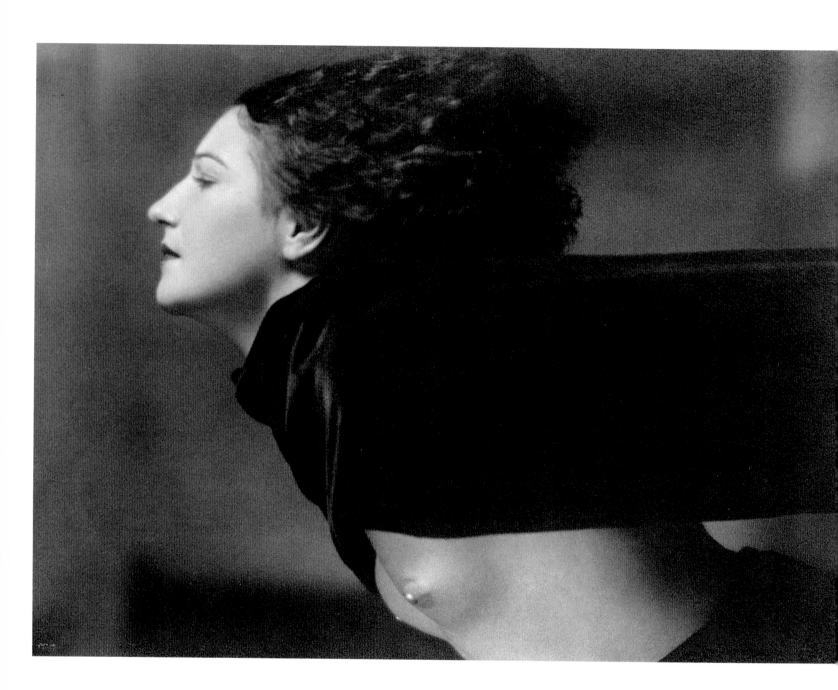

Matthias Harder

NELLY

Dresden · Athens · New York

From the Photographic Archive
of the Benaki Museum, Athens

Aus der Photographischen Sammlung
des Benaki-Museums, Athen

With a contribution by Irene Boudouri
Mit einem Beitrag von Irene Boudouri

Griechische
Kulturstiftung

Prestel
Munich · London · New York

This book has been published in conjunction with the exhibition / Dieses Buch erschien anläßlich der Ausstellung ›Nelly: Dresden · Athens · New York‹

The Editor and the Publisher would like to thank the following for their valuable contributions and assistance: the Benaki Museum, Athens, especially Prof. Angelos Delivorrias, director and Mrs. Fani Constantinou, curator of the Photographic Archives, for the generous loan of works; the Greek Cultural Foundation for the organization of the touring exhibition as part of the 'Greece 2001' venture; Dr. Eleftherios Ikonomou and Irene Boudouri for their textual contributions, as well as Dr. Bodo von Dewitz of Agfa Foto-Historama, Cologne, Charalampos Ioannou and Michael Laser of Chronika, Berlin, and Brigitte Waldach, Berlin, for their advice and support. / Herausgeber und Verlag danken dem Benaki-Museum, Athen, für die großzügigen Leihgaben, der Griechischen Kulturstiftung für die Organisation der Ausstellungstour im Rahmen von ›Griechenland 2001‹, Dr. Eleftherios Ikonomou und Irene Boudouri für ihre Textbeiträge sowie Dr. Bodo von Dewitz vom Agfa Foto-Historama, Köln, Charalampos Ioannou und Michael Laser von Chronika, Berlin, und Brigitte Waldach, Berlin, für Beratung und Unterstützung.

Photography / Photoaufnahmen der Plakate Costas Manolis, Athens

Chief photographic conservator / Chefrestaurator, Benaki-Museum
Maria Matta

Front cover / Auf dem Schutzumschlag: Nikolska in the Parthenon
Nikolska im Parthenon, Athens, 1929
Frontispiece / Frontispiz: Female portrait / Frauenporträt,
Athens (?), c. 1930

CIP-Kurztitelaufnahme der Deutschen Bibliothek
Ein Titeldatensatz für diese Publikation ist bei der Deutschen Bibliothek erhältlich

Library of Congress Control Number: 200 1089 180

Prestel Verlag · Mandlstraße 26 · 80802 München
Tel. (089) 381709-0 Fax (089) 381709-35
www.prestel.de

4 Bloomsbury Place · London WC1A 2QA
Tel. (0)20 7323-5004 Fax (0)20 7636-8004

175 Fifth Avenue, Suite 402 · New York, NY 10010
Tel. (212) 995-2720 Fax (212) 995-2733
www.prestel.com

Edited by / Redaktion Peter Stepan
English texts translated from the German by Nicholas Levis, Berlin,
except for Foreword, by Stephen Telfer, Edinburgh
Text by Irene Boudouri translated into English by John Leatham,
and into German by Nikolaus Schneider

Design Ulrike Schmidt
Lithography ReproLine, Munich
Druck und Bindung / Printing and binding Passavia, Passau

Printed in Germany on acid-free paper

ISBN 3-7913-2553-1

Contents / Inhalt

Foreword

Eleftherios Ikonomou
Director of the Griechische Kulturstiftung, Berlin

Generations of Greeks in the 20th century left their homeland behind and immersed themselves in foreign cultures. The main reasons they migrated were political turmoil and economic necessity, but they also went in search of training and education. The biography of Elli Soyoultzoglou—who worked under the name Nelly—largely mirrors this experience.

Migration has double-edged consequences: on the one hand, it uproots people and causes them to feel estranged from their homeland; on the other hand, life abroad enriches people's experience and brings numerous other benefits with it. In Nelly's case, her work is testimony to the thoroughly enriching experience gained from living abroad.

After her family fled Asia Minor, this young Greek woman of 20 moved to Dresden in 1920 where she first studied art, then photography. In 1924 she returned to Athens as a qualified photographer. Like many who followed in her footsteps, Nelly took back to Greece not only the technical skills she had acquired as a student, but also numerous other ideas and influences. Certainly the photographs from her time in Athens—especially of dancers on the Acropolis—which caused a scandal in Greece but which also brought her international acclaim, would not have been possible without the experience she had in Dresden.

Nelly's second lengthy stay abroad was again prompted by political turmoil in Europe. At the outbreak of war in 1939, she and her husband were in New York for the World Fair where Nelly was responsible for the interior decoration and furnishing of the Greek Pavilion. Nelly decided not to return to Athens and spent almost thirty years in the United States.

This volume surveys Nelly's multifaceted œuvre: portraits, records of Greek culture and country life, dance stills and images of New York City. As awareness of the photography of the 1920s—especially the work of women photographers—has grown, individual examples of Nelly's work have been exhibited over the past ten years.

The Foundation for Hellenic Culture is an official representative of Greek cultural policy abroad. It is delighted to bring to the attention of a wider audience the work of a 'cross-cultural' Greek artist. The cultural life of Greece in the 20th century has indeed been formatively influenced by such dialogue between the native and the foreign, as exemplified by Nelly.

Our thanks go to all our German and Greek partners who have lent their support.

Vorwort

Zentrale und lebensbestimmende Erfahrung für Generationen griechischer Bürger im 20. Jahrhundert war das Wandern und ›Erleben‹ zwischen der eigenen Kultur und der Fremde. Hauptgründe für diese Migration waren politische Wirren und ökonomische Bedürfnisse, Ausbildung und Erziehung. Die Biographie von Elli Souyoultzoglou, die sich später den Künstlernamen Nelly gab, folgt in großen Zügen diesen Erfahrungen. Die ambivalenten Auswirkungen solcher Migrationen sind bekannt: Entwurzelung und Entfremdung auf der einen Seite, aber im positiven Fall auch Bereicherung und Zugewinn. Im Falle Nelly zeugt ihr Lebenswerk von den bereichernden Wechselwirkungen, die aus solcher Wanderschaft resultieren.

Im Alter von 20 Jahren übersiedelt die junge Griechin 1920 nach Dresden. Dort studiert sie zuerst Malerei, danach Photographie. 1924 kehrt sie als diplomierte Kunstphotographin nach Athen zurück. Wie viele nach ihr nahm Nelly neben der erworbenen technischen und handwerklichen Expertise vielfältige Anregungen und Einflüsse nach Griechenland zurück. Gerade die Bilder aus Nellys Athener Zeit, vor allem die Tanzinszenierungen auf der Akropolis, die in Griechenland zum Skandalon wurden, ihr aber auch Renommee verschafften, wären ohne die Dresdner Erfahrung so nicht möglich gewesen.

Auch Nellys zweiter längerer Auslandsaufenthalt wurde durch politische Wirren in Europa verursacht. 1939, bei Kriegsbeginn, befand sie sich mit ihrem Mann gerade auf der Weltausstellung in New York. Nach dem Entschluß, nicht nach Athen zurückzukehren, lebte und arbeitete Nelly fast drei Jahrzehnte in den USA.

Indem die Ausstellung die einzelnen Stationen nachzeichnet, schafft sie einen Überblick über das wandlungsreiche Schaffen Nellys: Porträts, Dokumentation der griechischen Landschaft und Kultur, inszenierte Kunstphotos, New Yorker Stadtansichten. Der hier vorliegende Bildband ist konzipiert als Begleitkatalog zur ersten umfangreichen Einzelausstellung von Nellys Arbeiten im deutschsprachigen Raum. Die Griechische Kulturstiftung als offizielle Mittlerorganisation Griechenlands im Bereich der auswärtigen Kulturpolitik freut sich, hiermit die Arbeiten einer griechischen Künstlerin ›zwischen den Kulturen‹ einem breiten Publikum näher zu bringen.

Unser herzlicher Dank gilt allen deutschen und griechischen Partnern, die dieses Projekt initiiert und unterstützt haben.

The Photographic Collection of the Benaki Museum and the Nelly Archive

Photosammlung und Nelly-Archiv des Benaki-Museums

Irene Boudouri

The year 2000 was a notable one for the Benaki Museum: after a major expansion program over a period of ten years, and the reorganization and redesigning of its displays, the museum opened its doors to the public as the Museum of the Historical and Cultural Continuity of Hellenism. The Greek collections are now exhibited in the central, nineteenth-century, neoclassical building on Vassilissis Sophias Avenue, while the Oriental Art collections and the Historical and Photographic Archives are each housed in separate premises.

The transfer of the Photographic Archive to a property of three hundred square meters on nearby Philikis Etaireias Square sets it apart from the central museum structure. The archives now form a distinct department in their own right, given also that photography has gradually been foreaking the role it had previously acquired. This role of documenting the face of Greece and its characteristics, its monuments, the environment, and popular and religious occasions had been assigned to it when the Photographic Archive was founded in 1973.

The increasing acceptance of photography as a means of artistic expression, a better knowledge of the medium's physical properties and resultant conservation problems, combined with photographic developments on an international level, were the primary considerations that determined the restructuring of the museum's Photographic Archive. Particular attention has been paid to storage conditions with the provision of specially designed rooms kept at a constant temperature, and to the establishment of a conservation and restoration department. A specialized library and the loan of photographic material to exhibitions and for publications both in Greece and abroad encourage comparisons with other collections, while also placing the material in its historical context. With the installation of a darkroom and making prints from primary photographic material, the link between the theoretical and the practical approach to photography has been reestablished.

Today the Photographic Archive comprises 300,000 negatives and 25,000 original prints, acquired as gifts or through the purchase of the major photographic archives of professional and amateur photographers in Greece and elsewhere. Among twentieth-century collections are those of two outstanding Greek photographers: Voula Papaioannou (1898–1990), who recorded the period under German occupation and reconstruction after the war, life in the countryside and the Greek landscape, monu-

Das Jahr 2000 war für das Benaki-Museum ein besonderes. Nach einer zehnjährigen Umbauphase und der Neugestaltung des Ausstellungsbereichs öffnete es als Museum der griechischen Geschichte und Kultur seine Pforten für die Öffentlichkeit. Die griechischen Sammlungen werden jetzt in dem klassizistischen Gebäude auf der Vassilissis Sophias Avenue gezeigt, während die Sammlungen orientalischer Kunst sowie das historische und das Photoarchiv jeweils in eigenen Räumlichkeiten untergebracht sind.

Mit dem Umzug des Photoarchivs in ein Areal von 300 Quadratmetern Ausstellungsfläche in der Nähe des Philikis-Etaireias-Platzes hat es sich von der zentralen Museumsstruktur gelöst. Im doppelten Sinne ist es jetzt eine selbständige Abteilung, zumal sich die Photographie inzwischen von ihrer dienenden Rolle befreit hat, die ihr noch 1973 bei der Gründung des Photoarchivs zugewiesen worden war und die darin bestand, das Antlitz Griechenlands – Denkmäler, Natur, volkstümliche und religiöse Feste – zu dokumentieren.

Die Akzeptanz der Photographie als selbständige künstlerische Größe, Respekt vor ihrer physischen Substanz und die sich hieraus ergebende Notwendigkeit ihrer Bewahrung und Rückbindung an internationale photographische Entwicklungen waren für die Konzeption der neuen Museumsstruktur maßgebend. Besondere Aufmerksamkeit wurde daher auf die Aufbewahrung des Photomaterials in eigens hierfür entworfenen, gleichmäßig temperierten Räumen und die Einrichtung einer Restaurierwerkstatt verwandt. Die Gründung einer Photobibliothek und die ständige Präsentation der photographischen Bestände in Ausstellungen und Publikationen in Griechenland und im Ausland laden zu Vergleichen mit anderen Sammlungen ein und stellen die gezeigten Werke zugleich in einen historischen Kontext. Durch den Betrieb eines Labors und die Herstellung von Abzügen von photographischem Originalmaterial sind Theorie und Praxis wieder eng miteinander verknüpft.

Das Photoarchiv umfaßt heute ungefähr 300 000 Negative und 25 000 Originalabzüge (Vintageprints), ein Bestand, der vor allem auf Schenkungen und Ankäufen umfangreicher Sammlungen basiert, die von griechischen und ausländischen Berufs- und Amateurphotographen zusammengetragen wurden. Zu den großen Sammlungen des Archivs aus dem 20. Jahrhundert gehören diejenigen der beiden herausragenden griechi-

ments and antiquities; and Nelly (1899–1998), to whom this volume is dedicated. These are complemented by the archive amassed by D.A. Harissiadis (1911–93). Harissiadis is an internationally renowned photographer, whose early photographs are of the Albanian campaign (1940–41) and the German Axis. Later on he founded the D.A. Harissiadis Photographic Agency that specialized in photographs for industrial and development projects, advertising, and Greek shipping. To these must be added the photographic archive of Pericles Papachatzidakis (1905–90) who made a systematic record of traditional Greek settlements and Byzantine monuments, and that of Nicholaos Tombazis (1898–1986) whose chief interest lay in archaeological excavations and ancient monuments, as well as Indian subjects, which he photographed extensively.

Among amateur photographers of a privileged class, who by and large focussed on the Greek landscape, everyday life in the countryside, and Greek monuments, are Loukas Benakis, Ioannis Haramis, Stephanos Malikopoulos, and Elli Papadimitriou. Rena Andreadi, Nikos Rizos, and Laskarina Boura concentrated on the monuments of the Byzantine era. Donations of important photographic archives include those of the architects Maria Zagorissiou and Charalambos Sphaellos, whose focus is on documenting buildings and styles.

The historical dimension of photography is evident in the collection of Henri Paul Boissonnas (1894–1966), the son of the distinguished Swiss photographer Fred Boissonnas who covered the surprise attack made by the Greek army on Asia Minor in 1921, and the collections donated by the photographers Kostas Balaphas and Spyros Meletzis, both of whom depicted the Greek Resistance and partisan fighting in the mountain regions (1940–46).

The nineteenth century is represented by two important European photographers: the Frenchman Alfred Nicolas Normand (25 photographs of monuments on the Acropolis taken in 1851–52), and the English-born photographer James Robertson (46 pictures of antiquities, chiefly of the Acropolis, 1853–54). Works by the most famous Greek photographers of the nineteenth century (among them Philippos Margaritis, Dimitrios Konstantinou, Petros Moraïtis, the Romaïdis Brothers, Konstantinos Athanassiou, Xenophon Vathis, and Georgios Boukas) are included in the archives, while a determined effort is being made to assemble works by all those who recorded nineteenth-century Greece.

On account of its artistic quality, Nelly's gift to the photographic department of the Benaki Museum in 1985 not only coincided with, but also gave further impetus to, a change in attitude towards photography. An extensive exhibition of photographic scenes of nineteenth-century Athens—Athens 1839–1900: Photographic Records—had just been held at the Benaki Museum. From that point on and as a means of acknowledging the "most outstanding woman in Greek photography,"

schen Photographen: Voula Papaioannou (1898–1990), dessen humaner Blick die Jahre der deutschen Besetzung und des Wiederaufbaus sowie das Landleben, die griechische Landschaft, die Monumente und Baudenkmäler festhielt, und Nelly (1899–1998), der dieser Band gewidmet ist. Daneben besteht das von D. A. Harissiadis (1911–1993) zusammengetragene Archiv. Schwerpunkt dieses international anerkannten Photographen war der Widerstand der Griechen gegen die Italiener im Albanienfeldzug (1940–1941) und die deutsche Besetzung. Später gründete er die Photoagentur D. A. Harissiadis, die sich auf Industriephotographie, Werbung, Entwicklungsprojekte, öffentliche Bauten und die griechische Schiffahrt spezialisierte. Hinzu kommen das Photoarchiv von Perikles Papachatzidakis (1905–1990), der eine systematische Dokumentation traditioneller griechischer Wohnstätten und byzantinischer Monumente erstellte, sowie das von Nicholaos Tombazis (1898–1986), dessen Hauptinteresse archäologischen Ausgrabungen, antiken Monumenten und indischen Motiven galt, die er ausgiebig photographierte.

Zu den herausragenden Amateurphotographen, die oftmals die griechische Natur, den Alltag auf dem Land und Altertümer dokumentierten, zählen Loukas Benakis, Ioannis Haramis, Stephanos Malikopoulos und Elli Papadimitriou. Rena Andreadi, Nikos Rizos und Laskarina Boura richteten ihr Augenmerk auf byzantinische Monumente. Unter den bedeutenden Schenkungen von Photoarchiven befinden sich diejenigen der Architekten Maria Zagorissiou und Charalambos Sphaellos, in deren Mittelpunkt die Architekturphotographie steht.

Die historische Dimension der Photographie kommt in den Archiven von Henri Paul Boissonnas (1894–1966) zum Tragen, des Sohnes des hervorragenden Schweizer Photographen Fred Boissonnas, der in seinen Bildern den Überraschungsangriff der griechischen Armee 1921 auf Kleinasien festhielt, sowie von den Photographen Kostas Balaphas und Spyros Meletzis, die beide den griechischen Widerstand und den Partisanenkrieg in den Bergen dokumentiert haben.

Das 19. Jahrhundert vertreten zwei bedeutende europäische Photographen: der Franzose Alfred Nicolas Normand (25 zwischen 1851 und 1852 entstandene Photographien von Monumenten auf der Athener Akropolis) und der in England geborene James Robertson (46 Photographien von Altertümern, vor allem auf der Akropolis, 1853–54). Die bedeutendsten griechischen Photographen des 19. Jahrhunderts (unter ihnen Philippos Margaritis, Dimitrios Konstantinou, Petros Moraitis, die Brüder Romaidis, Konstantinos Athanassiou, Xenophon Vathis und Georgios Boukas) sind im Archiv vertreten, und es werden große Anstrengungen unternommen, die Werke sämtlicher Photographen zusammenzutragen, die Griechenland im 19. Jahrhundert dokumentiert haben.

Nellys Schenkung an die Photographieabteilung des Benaki-Museums im Jahr 1985 fiel in eine Zeit, in der sich die allge-

the Photographic Archive has regularly promoted Nelly's work through exhibitions and publications. Setting aside the rediscovery of her work by the distinguished journalist Eleni Vlachou, writing for *Kathimerini* in 1975, Nelly had long been neglected by the art world in its appraisal of photographic work. She was brought back into the limelight in 1983 when a film dedicated to her life and work, directed by Vera Palma and written by Alkis Xanthakis, was released.

The exhibition Portraits by Nelly: 1920–1940 was the first to deal with the most important element in her œuvre—namely, portraiture—to which the artist consistently devoted herself in Germany, Greece and America. A retrospective view of her work, Nelly's Inter-War Photographs, held in 1987, brought the public face-to-face with Nelly's image of Greece between the wars. An essay by Demosthenis Agraphiotis in the catalogue analyzes the photographer's concept, chiefly in respect of its semiotic content. For the first time, this exhibition succeeded in drawing the public's attention to the remarkable range of Nelly's subjects. A succession of shows on individual themes was mounted in the years that followed. Nelly's Santorini 1925–1930 highlighted both the artistic and documentary aspects of her work on settlements and the landscape of the island of Santorini that was soon to undergo dramatic changes. As a means of self-assessment and aware as to how it would provide the best reference for understanding her work, Nelly published her autobiography, helped by the scholar Emmanuel Kasdaglis who possessed the rare skill of being able to draw out personal details. A meeting in 1990 between Nelly and Dionysis Fotopoulos, both artists with strong personalities, led to the publication of *Nelly*, a book which, rich in pictorial material, summarizes the photographer's life and work. It also includes an essay by Alkis Xanthakis, placing Nelly in a photo-historical context, and a stylistic analysis by Euridice Trichon-Missanli.

Material from Nelly's archive was first displayed abroad in 1990 in a group exhibition in Germany, where she had begun her career as an artist. Her model on the Acropolis had been the athlete Karabatis whose innermost nature and classical profile embodied to perfection the title of the exhibition, Greece through the Eyes of the Soul (Das Land der Griechen mit der Seele suchen), instigated by Agfa Foto-Historama and held in Cologne. Extensive references are made to Nelly in the catalogue dedicated to her teacher Hugo Erfurth, *Hugo Erfurth, Photograph zwischen Tradition und Moderne*, Agfa Foto-Historama, Cologne 1992. The exhibition Nelly's Sacred Marbles, showing an important group of ancient sculpture, was mounted in Barcelona. The same subject was the theme of the exhibition Nelly : Body, Light and Ancient Greece and the accompanying catalogue presented in the same city as part of the Cultural Olympiad two years later, in 1992. It illustrated her interpretation of the ancient world, strongly influenced by her apprenticeship period in Germany. In 1994 she was included in the monu-

meine Einstellung zur Photographie zum Positiven wendete, und verlieh dieser Entwicklung zusätzlichen Nachdruck. Unmittelbar davor war im Benaki-Museum eine umfassende Ausstellung von Photographien Athens im 19. Jahrhundert gezeigt worden: ›Athen 1939–1990: Photographische Dokumente‹. Seither hat das Photoarchiv in Ausstellungen und Publikationen regelmäßig auf die Arbeiten dieser bedeutenden Photographin aufmerksam gemacht. Abgesehen von der Wiederentdeckung ihres Werks durch die Journalistin Eleni Vlachou in einer 1975 erschienenen Ausgabe von *Kathimerini* war Nelly in der Kunst- und Photoszene lange Zeit nicht zur Kenntnis genommen worden. Doch als 1983 ein ihr gewidmeter Film zu sehen war (Regie: Vera Palma, Drehbuch: Alkis Xanthakis), stand sie plötzlich wieder im Rampenlicht.

Die Ausstellung ›Porträts von Nelly: 1920–1940‹ war die erste, die sich mit dem eigentlichen Schwerpunkt ihres Œuvres, der Porträtkunst, auseinandersetzte. Eine Retrospektive ihrer Werke, Nellys Photographien zwischen den Kriegen (1987), konfrontierte das Publikum mit Nellys Griechenlandbild jener Zeit, das von Demosthenis Agraphiotis im gleichnamigen Ausstellungskatalog vor allem im Hinblick auf seinen semiotischen Gehalt analysiert wurde. Bei dieser Gelegenheit wurde die Öffentlichkeit erstmals auf Nellys thematische Vielfalt aufmerksam. In den folgenden Jahren widmeten sich mehrere Ausstellungen einzelnen Segmenten dieses Spektrums. Das Album *Nellys Santorin 1925–1930* (Athen 1987) veranschaulicht sowohl die künstlerische als auch die dokumentarische Dimension der Aufnahmen Nellys von Wohnhäusern auf jener Insel, deren Erscheinungsbild sich schon kurze Zeit später stark verändern sollte. Als Versuch einer Standortbestimmung und im vollen Bewußtsein, daß dies die beste Grundlage für das zukünftige Verständnis ihres Werkes sein würde, veröffentlichte Nelly ihre Autobiographie, bei der ihr der Wissenschaftler Emmanuel Kasdaglis mit seiner seltenen Fähigkeit, Menschen plastisch in Erscheinung treten zu lassen, zur Seite stand. Ein Treffen zwischen zwei Künstlern, die beide eine starke Persönlichkeit besaßen, führte 1990 zur Publikation von Dionysis Fotopoulos: *Nelly*, ein Buch, das ihr Lebenswerk anhand reichen Bildmaterials, der präzisen Bestimmung ihres Platzes in der griechischen Photographie durch Alkis Xanthakis und einer Stilanalyse von Euridice Trichon-Missanli auf vollendete Weise zusammenfaßt.

Im Ausland wurde Material aus Nellys Archiv erstmals 1990 in einer Gruppenausstellung in Deutschland gezeigt, wo ihre Karriere begonnen hatte. Eines ihrer Modelle auf der Akropolis war der Athlet Karabatis gewesen, dessen Wesen und klassisches Profil den Titel dieser vom Agfa Foto-Historama in Köln präsentierten Ausstellung ideal verkörperte: ›Das Land der Griechen mit der Seele suchen‹. Ausführlich Bezug genommen wird auf Nelly in dem ihrem Lehrer Hugo Erfurth gewidmeten Katalog *Hugo Erfurth, Photograph zwischen Tradition*

mental work by Naoumi Rosenblum, *A History of Women Pho-tographers*, Abbeville Press Publishers, New York, and in the cat-alogue of women photographers during the Weimar Republic, Photographieren hiess teilnehmen – Photographinnen in der Weimarer Republik published by Museum Folkwang Essen. The publications *The Pottery Workshops of Marousi* in 1930 as seen in 46 photographs by Nelly and *Nelly's: A Glance at Urban Occu-pation in the Inter-War Years*, published in 1994, provide a cross-section of subjects of specialist interest which she treated in minute detail. They reveal another Nelly, one different to the first, indeed virtually in conflict with it. The painstaking accu-racy with which occupation is recorded, the exhaustive photo-graphic analysis of the potter's craft from the soaking of the clay to the creation of the pot astonish even those familiar with these skills.

The volume *Angelos Seraïdaris: Photographic Itinerary on Mount Athos, 1935*, compiled by Fani Constantinou, the Cura-tor of the Photographic Archive, and published in 1995, signals the artistic divergence in the works of Angelos Seraïdaris and his wife Nelly, and resolves any previous confusion over who photographed what. At the same time, it reveals the infectious teaching of Nelly, as well as the assimilative capacity of her hus-band who apprenticed himself to her. Another publication, *Nelly's The Old City of Athens*, with an introduction and explanatory notes by D.G. Kambouroglou, redresses the imbal-ance of a failed previous publishing effort by Nelly and the his-torian Kambouroglou in the 1920s which aimed at recording the old city of Athens lying at the foot of the Acropolis.

Nudes on the Acropolis and pictures of dancers: Nelly's Body and Dance, a major exhibition held in Kalamata in 1997 and its accompanying catalogue, displayed the artist's photo-graphs of dancers, successfully scotching any scandal-seeking approach to the subject. Indeed, the exhibition placed Nelly among the leading international dance photographers active between the wars.

Other retrospective exhibitions followed, the most impor-tant one being Nelly's: From Athens to New York, shown in 1997 at the International Center of Photography in New York, before touring to Shizuoka, Japan, in 1999.

This account of Nelly's rich œuvre cannot provide an in-depth study of the vast wealth of material in the archive. The limited number of photographs that Nelly herself printed—about half a percent of all images she took—explains the rela-tive frequency with which some subjects are to be seen at exhi-bitions or in a number of publications, all of which depended uniquely on original material. Simultaneously, an important question has been raised with regard to posthumous meddling with the photographer's own choices. In addition, the Museum Archive bears a dual responsibility, namely of preserving the established image and standing of the photographer, while also overseeing the management of the pictures produced through

und Moderne (Agfa Foto-Historama, Köln, 1992). In Barcelona organisierte man die Ausstellung ›Nellys heilige Marmorbild-werke‹, eine bedeutende Gruppe antiker Skulpturen. Demsel-ben Thema widmete sich die Ausstellung ›Nelly: Körper, Licht und das antike Griechenland‹, die zwei Jahre später, 1992, ebenfalls in Barcelona im Rahmen der Kulturolympiade gezeigt wurde. Der dazu erschienene Katalog veranschaulicht, wie nachhaltig ihre Sicht der Antike von ihrer Ausbildung in Deutschland geprägt worden war. 1994 wurde Nelly in das monumentale Werk von Naomi Rosenblum, *A History of Women Photographers* (Abbeville Press Publishers, New York), und in den vom Museum Folkwang in Essen veröffentlichten Katalog, *Photographieren hieß teilnehmen – Photographinnen in der Weimarer Republik*, aufgenommen. Die Publikationen *Die Töp-ferwerkstätten von Marousi im Jahr 1930 in 46 Photographien von Nelly* und *Nelly – Ein Blick auf die städtischen Gewerbe in den Jah-ren zwischen den Kriegen* (1994) bieten einen Einblick in mit großer Liebe zum Detail behandelte Themen. Sie zeigen eine andere Nelly, die sich deutlich von der ersten unterscheidet, ja in einem gewissen Widerspruch zu dieser steht. Die gewissen-hafte Präzision, mit der die einzelnen Gewerbe dargestellt wer-den, die ausführliche photographische Dokumentation des Töpferhandwerks, vom Befeuchten des Tons bis zur Herstel-lung des Topfes, erstaunt selbst diejenigen, die mit diesen Tätigkeiten vertraut sind.

Das Album Angelos Seraidaris, *Photoreise zum Berg Athos 1935*, das 1995 erschien und von der Kuratorin des Photoar-chivs des Benaki-Museums, Fani Konstantinou, zusammenge-stellt wurde, grenzt den künstlerischen Beitrag Angelos Serai-daris' von dem seiner Frau Nelly ab und beseitigt jede frühere Unklarheit darüber, wer welche Bilder gemacht hat. Es ver-deutlicht, wie prägend Nellys Vorbild war, aber auch die Anpassungsfähigkeit ihres Mannes Angelos, der bei ihr lernte. Ein weiteres Buch, *Nellys Altstadt von Athen*, mit einer Einlei-tung und Anmerkungen von D. Gr. Kambouroglou, wiederholt mit Erfolg ihren in den 1920er Jahren gescheiterten Versuch, die Altstadt Athens am Fuße der Akropolis photographisch zu dokumentieren.

Handelt es sich um Nackte auf der Akropolis oder um Tanz-photographien? ›Nellys: Körper und Tanz‹, die große Ausstel-lung, die 1997 in Kalamata zu sehen war, und der Katalog basie-ren auf Nellys Aufnahmen von Tänzern und entzogen jeglicher auf einen Skandal abzielender Annäherung an das Thema den Boden. Nelly wurde durch sie international zu einer der führen-den Tanzphotographinnen der Zwischenkriegszeit.

Es folgten weitere Ausstellungen, deren bedeutendste ›Nelly: From Athens to New York‹ war, die 1997 im Internatio-nal Center of Photography in New York und 1999 im japani-schen Shizuoka gezeigt wurde.

Alle genannten Projekte stellen keine vollständige Aufzäh-lung der unerschöpflichen Schätze im Nelly-Archiv dar. Die

the systematic printing of all negatives. Indicative of this mass are groups of pictures covering subjects such as the Greek countryside, archaeological objects in museums, Greek fashion, trade exhibitions and the so-called "industrial" pictures taken in the port of Piraeus.

A future priority of the Photographic Archive is to organize an exhibition of Nelly's pictures taken in America (1939–55), to be accompanied by two publications—one on the Greeks in America whom she recorded in considerable detail, producing images of their social life, public events, portraits, and interior shots, and a second on Nelly's photographic work used for advertising purposes.

The original photographs reproduced in this publication were selected according to their connection with wider trends in the field of photography while, at the same time, disclosing Nelly's aesthetic roots. In addition, Nelly had always expressed the wish that she be made known in Germany, the country that acted as a catalyst to her artistic career. This volume goes some way to fulfilling this wish.

begrenzte Zahl von Photographien, von denen sie selbst Abzüge anfertigte – nur ein halbes Prozent der Gesamtproduktion –, erklärt die relative Häufigkeit, mit der einige ihrer Werke ausgestellt und die verschiedenen Publikationen, die ausschließlich auf Originalmaterial basieren, wiederaufgelegt wurden. Zugleich stellt sich in diesem Zusammenhang die schwierige Frage, inwieweit künstlerische Entscheidungen der Photographin postum modifiziert werden dürfen. Darüber hinaus obliegt dem Museumsarchiv nicht nur die Aufgabe, das Ansehen und etablierte Bild der Photographin zu bewahren, sondern auch der Umgang mit einer Unmenge von Abbildungen, den systematisch angefertigten Abzügen sämtlicher Negative. Charakteristische Beispiele für diese Bildermasse sind ihre Aufnahmen der griechischen Landschaft, archäologischer Exponate in Museen, griechischer Mode, Handelsausstellungen und die sogenannten ›Industrie‹-Bilder, die im Hafen von Piräus entstanden.

Zu den zukünftigen Schwerpunkten des Photoarchivs gehören Ausstellungen der Aufnahmen, die Nelly in Amerika (1939–1955) machte, begleitet von zwei Publikationen, die dem Leben der Griechen in Amerika gewidmet sind, das sie minutiös dokumentierte (öffentliche Ereignisse, Porträts, Interieurs), sowie ihrer Werbephotographie.

Die Originalaufnahmen für die vorliegende Publikation wurden unter dem Gesichtspunkt ausgewählt, daß sie in einem Zusammenhang mit übergreifenden Tendenzen in der Photographie stehen und die Wurzeln von Nellys Ästhetik veranschaulichen. Zugleich erfüllt dieser Band Nellys expliziten Wunsch, in Deutschland, dem Land, das als Katalysator für ihre künstlerische Laufbahn diente, eine breitere Öffentlichkeit mit ihrem Werk bekannt zu machen.

Portraits, Dance, and Temple—
A Photographic Synthesis

From Sepia Pictorialism to Snapshot Journalism

Matthias Harder

The history of photography in Greece would seem mainly to be a photographic record of the Survival of the Classics. Until the Renaissance, ancient Greece was always viewed through the filter of Roman aesthetics. The later discovery and unearthing of Roman, Etruscan and Greek sculptures starting in the 16th century led to a reevaluation of ancient art. Later, the obligatory Grand Tour gave English and French nobility the opportunity to survey and sketch temple ruins in southern Italy and Sicily. The high point of worshiping all things Italian was reached around 1800, a time when Ottoman-occupied Greece was seldom on the Western traveler's itinerary. In later decades, a few cultured travelers and archaeologists started braving the dangers and lack of infrastructure and ventured into Greece. Among them, following the development of the daguerreotype in 1839, were more than a few pioneers of the new medium of photography. Their prints of classical ruins quenched the thirst for edification among those who stayed home. The Greek victory in the War of Independence (1821–29) and the Wittelsbach regime of the 1830s paved the way for more travel from the West. The images and motifs favored by resident and traveling photographers tended to stimulate the rudimentary tourist industry that arose in Greece at the end of the 19th century.[1]

Dresden (1920–1924)
Learning Photography under Hugo Erfurth and Franz Fiedler

Nelly was 20 years old when she witnessed the destruction of her hometown in 1919. Her family was forced to flee and settle in nearby Smyrna. In 1920, she left her Greek community in Asia Minor for Germany, following her brother Nikos to Dresden. There, she at first studied painting under Ernst Oskar Simonson-Castelli. Hoping to also learn music in Germany, she took private piano lessons. After a year she switched from painting to photography, as many other artists were doing at the time. The Greek honorary consul in Dresden, a friend of the family's, introduced Nelly to the well-known photo portraitist, Hugo Erfurth.[2] At his studio in the Palais Lüttichau, Erfurth instructed Nelly and two other students in the techniques of portraiture, the photographic reproduction of art works, and a variety of coloration and pigment processes for photo prints using Bro-

Porträts, Tanz, Tempel –
eine photographische Synthese

Von den piktorialistischen Edeldruckverfahren zum Bildjournalismus

Die Geschichte der Photographie in Griechenland scheint in erster Linie eine Geschichte der photographischen Antikenrezeption zu sein. Der Blick auf die griechische Antike war bis zur Renaissance stets durch die Ästhetik der Römer vermittelt. Die Entdeckung und Ausgrabung römischer, etruskischer oder griechischer Skulpturen führte seit dem 16. Jahrhundert zu einer Neubewertung antiker Kunst. Die für den englischen und französischen Adel obligatorische Grand Tour bot später die Gelegenheit, insbesondere die Tempelruinen in Süditalien und Sizilien zu vermessen und zu zeichnen. Um 1800 war der Höhepunkt der Italiensehnsucht erreicht, während Griechenland wegen der türkischen Besetzung selten auf der Reiseroute lag. Doch trotz aller Gefahren und der kaum vorhandenen Infrastruktur brachen einige Kulturreisende und Archäologen in Richtung Griechenland auf – und im Zuge der Erfindung und Bekanntgabe der Photographie 1839 auch einige Pioniere dieses Mediums. Sie stillten mit ihren Aufnahmen der klassischen Ruinen den Bildungshunger der Daheimgebliebenen. Nach dem für die Griechen gewonnenen Freiheitskampf markierte die Wittelsbacher Herrschaft seit den 1830er Jahren einen Wendepunkt in der Erschließung des Landes. Zum Ende des Jahrhunderts entwickelte sich ein früher Tourismus in Griechenland, der der Bildsprache der reisenden und in Griechenland ansässigen Photographen eine neue Richtung gab.[1]

Dresden (1920–1924)
Ausbildungszeit bei Hugo Erfurth und Franz Fiedler

1919 erlebte Nelly im Alter von zwanzig Jahren die Zerstörung ihres Heimatortes; die Familie mußte ins nahe Smyrna übersiedeln. 1920 verließ sie ihre griechische Heimat in Kleinasien Richtung Deutschland. Sie folgte ihrem Bruder Nikos nach Dresden und studierte zuerst Malerei bei Ernst Oskar Simonson-Castelli. Sie beabsichtigte in Deutschland auch Musik zu studieren, so nahm sie gleichzeitig privat Klavierstunden. Bereits im folgenden Jahr wechselte sie – wie andere Künstler dieser Zeit – von der Malerei zur Photographie. Der griechische Honorarkonsul in Dresden, ein Freund der Familie, empfahl Nelly dem bekannten Porträtisten Hugo Erfurth.[2] In dessen Atelier im Palais Lüttichau ließ sie sich neben zwei anderen

moil, charcoal, rubber, and oils. Nelly was later taught by Franz
Fiedler, a former student of Erfurth's who was nearly a genera-
tion older than her. Fiedler occasionally took portraits of
dancers at his studio, and Nelly began to assist him. She worked
with him in 1923 on nudes and dance photos set in a mountain-
ous region of Eastern Germany known as Saxon Switzerland,
shooting pictures in the wilderness of expressive dancers from
the school founded by Mary Wigman in Dresden in 1921.

Starting in 1909, Sergei Diaghilev, Igor Strawinsky, and
Pablo Picasso collaborated in revolutionizing traditional ballet
dancing by combining music, the stage set and dance itself into
a single entity. Around the same time, Isadora Duncan founded
her school for modern dance in Berlin. The new ideal demand-
ed that dance motions derive directly from the natural motions
of the human body—while also giving expression to the classi-
cal Greek laws of harmony. Artistic dance, which later came to
be known as expressive dance, was no longer centered on the
acrobatics of a graceful dancer, but on a "truthfulness of danced
expression that can arise only from the harmony of man and
nature."[3] Dance was understood as a direct expression of spiritu-
al experience, far beyond the stylistic conventions of ballet or
the mere act of interpreting music. Expressive dancers per-
formed barefoot, and wore clothing intended to allow free,
improvised movement. The idea that the human body could be
liberated physically and emotionally from historic dance cos-
tume, the constraints of dance tradition and its canon of
motions, and from the static stage-set sparked a revolution in
contemporary dance.

Starting around 1910, dancers worked with photographers
in producing images "in which the novelty of dance routines is
merged with a correspondingly modern visual design."[4] Erfurth,
Fiedler, and Nelly were preceded in the artistically congenial
photographic documentation of expressive dance by photogra-
phers like Arnold Genthe and Adolphe de Meyer with their
photographic series of Isadora Duncan and Vaclav Nijinski.

Modern expressive dance[5] and the dance photography of the
1920s found their most devoted exponents in Germany. Next to
Wigman and Duncan, Valeska Gert and Gret Palucca were
active as dancers in Dresden und Berlin, and it followed almost
automatically that the currents of modern dance photography
arose in those two cities. Among Nelly's fellow photographers in
this field were Charlotte Rudolph, Lili Baruch, Erna Lendvai-
Dircksen, Minya Diez-Dührkoop, and Madame d'Ora.

Independently of each other, the Erfurth students Fiedler
and Nelly and the Naumburg-based architectural photographer
Walter Hege all later chose the same travel destination, Greece.
Fiedler toured the country for ten weeks in 1929. He described
his impressions of a "tremendously strong light, equally harsh
and mild" and his attempts to capture the hue and tone of that
light with Autochrome plates.[6] Fiedler also toured Greece
together with Nelly, as a few shared motifs in their works

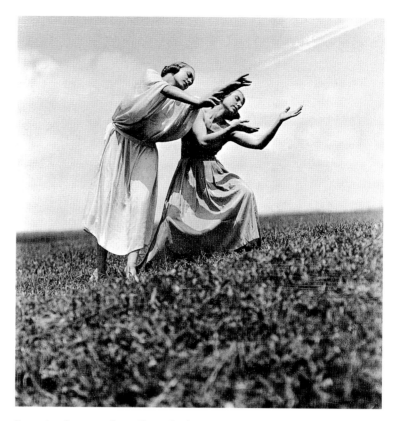

Expressive dancers in Saxon Switzerland, c. 1923
Ausdruckstänzerinnen in der Sächsischen Schweiz, um 1923

Schülern in der Bildnisphotographie, der photographischen
Kunstreproduktion und verschiedenen Edeldruckverfahren
(Bromöl-, Kohle-, Gummi- und Pigmentdruck) ausbilden. Spä-
ter unterrichtete sie Franz Fiedler, ebenfalls ein Erfurth-Schüler
und beinahe eine Generation älter als Nelly. Fiedler porträtier-
te in seinem Studio von Zeit zu Zeit auch Tänzerinnen; und
Nelly assistierte ihm. In dieser Zeit, 1923, arbeiteten sie
gemeinsam an einer Serie von Akt- und Tanzaufnahmen in der
Sächsischen Schweiz. Dort photographierte sie junge Aus-
druckstänzerinnen aus der Schule von Mary Wigman, die 1921
in Dresden gegründet wurde, in der freien Natur.

Bereits 1909 war der traditionelle Ballettanz durch die
Zusammenarbeit von Sergej Diaghilew, Igor Strawinsky und
Pablo Picasso in Paris revolutioniert worden, indem die Musik,
die Bühnengestaltung und der Tanz selbst zu einer Einheit ver-
schmolzen. Etwa gleichzeitig begründete Isadora Duncan in
Berlin eine Schule für modernen Tanz. Die Tanzbewegungen
sollten ihrer Lehre entsprechend aus den Gesetzmäßigkeiten
des menschlichen Körpers abgeleitet werden und gleichzeitig
die Harmoniegesetze der klassisch-griechischen Antike beto-
nen. Im künstlerischen Tanz, später Ausdruckstanz genannt,
stand weniger der anmutige Tänzer mit akrobatischen Bewe-
gungen als vielmehr »die Wahrhaftigkeit im tänzerischen Aus-
druck, die nur aus der Harmonie zwischen Mensch und Natur

evince.[7] Walter Hege visited Nelly's studio in Athens on his first tour of Greece in 1928. In the course of three book projects published by the Deutscher Kunstverlag in the 1930s, Hege became the most important German photographer of Greece alongside Herbert List.[8] For her part, Nelly's interests during the late 1920s went beyond Hege's exclusive focus on ancient temples. She was also interested in portraits, genre scenes, still-lifes, dance, and landscape photography.

Today Erfurth's name is associated with a classic form of studio photography that used large cameras and was meticulous in composition. Erfurthian aesthetics guided Nelly's portrait photography from the 1920s until the 1950s. By contrast, Franz Fiedler relied on middle-format cameras. Starting in 1925, he made use of a small-format Leica in his open-air work and, remarkably, in studio shoots.[9] This also seems to have inspired Nelly to use cameras with small negative formats for her nude/dance series in Saxon Switzerland, as these allowed faster and more spontaneous response to the movements of the models. Six of Nelly's nudes were printed in a volume called *Ideale Körper-Schönheit* (Ideal Body Beauty), published in 1924 by Vitus Verlag in Dresden, along with three photos by Fiedler and other stills by Magnus Weidemann, Lotte Herrlich, and Kurt Oelzner.[10] The contents page included a note that "all of the numbered illustrations are available for purchase in various sizes."[11]

Similar books were published at the time by Dresdner Verlag der Schönheit, which had initiated the periodical Die Schönheit (Beauty) in 1904. This "Monthly Journal for Art and Life,"

Nude portrait, early 1920s, from 'Ideal Body Beauty'
Aktporträt, frühe 20er Jahre, aus *Ideale Körper-Schönheit*

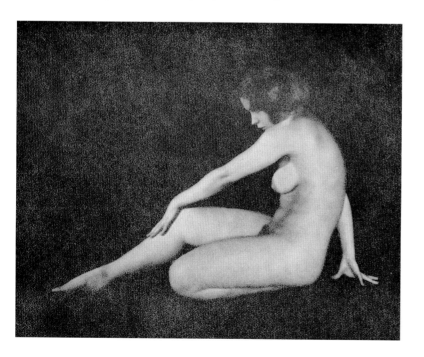

entstehen kann«, im Vordergrund.[3] So sollte seelisches Erleben unmittelbar tänzerisch ausgedrückt werden, was über die Stilisierung des Balletts oder eine reine Interpretation der Musik weit hinausging. Die Tänzerinnen traten meist barfuß auf und trugen Kleidung, die ihnen freie, improvisierte Bewegungen erlauben sollte. Diese Vorstellung einer physischen und emotionalen Befreiung des Körpers vom historischen Tanzkostüm, vom Zwang der Tanztradition und ihrem Bewegungskanon sowie der statischen Bühnensituation revolutionierte den zeitgenössischen Tanz.

Ab 1910 entstanden in Zusammenarbeit zwischen Tänzern und Photographen Aufnahmen, »in denen sich die Neuartigkeiten der Tanzschöpfungen in engster Weise mit einer entsprechend modernen Bildgestaltung verband«.[4] Zu den Vorläufern von Erfurth, Fiedler und Nelly innerhalb einer künstlerisch kongenialen photographischen Dokumentation des Ausdruckstanzes gehörten Arnold Genthe und Adolphe de Meyer mit ihren Bildserien von Isadora Duncan oder Waclaw Nijinski.

Der moderne Ausdruckstanz[5] und die Tanzphotographie hatten vor allem im Deutschland der zwanziger Jahre viele Vertreterinnen: Neben Wigman und Duncan arbeiteten Valeska Gert oder Gret Palucca in Dresden und Berlin. So entwickelte sich dort fast zwangsläufig auch eine moderne Tanzphotographie. Zu Nellys Kolleginnen zählten Charlotte Rudolph, Lili Baruch, Erna Lendvai-Dircksen, Minya Diez-Dührkoop und Madame d'Ora.

Unabhängig voneinander wählten die Erfurth-Schüler Fiedler, Nelly und der Naumburger Architekturphotograph Walter Hege später ein gemeinsames Reiseziel: Griechenland. Fiedler bereiste 1929 zehn Wochen das Land und beschrieb seine Eindrücke des »unerhört starken, zugleich scharfen und milden Lichts« und seine Erfahrungen mit Autochromplatten, die der Farbigkeit in Griechenland am nächsten kämen.[6] Fiedler und Nelly sind auch gemeinsam in Griechenland unterwegs gewesen, wie Motivüberschneidungen im Werk beider Photographen belegen.[7] Walter Hege besuchte seine Kollegin im Jahr zuvor bei seinem ersten Griechenlandbesuch in ihrem Athener Atelier. Er avancierte in den dreißiger Jahren durch drei Buchprojekte des Deutschen Kunstverlages neben Herbert List zum bedeutendsten deutschen Griechenlandphotographen.[8] Im Gegensatz zu Hege interessierte sich Nelly Ende der zwanziger Jahre nicht nur für die Photographie antiker Tempel, sondern auch für andere Bildgattungen: Porträt, Genre, Stilleben, Tanz- und Landschaftsphotographie.

Der Name ihres Lehrers Hugo Erfurth steht heute für eine klassische Atelierphotographie unter Verwendung großer Studiokameras und Betonung einer präzisen Komposition der Bildnisse. Diese ästhetischen Grundlagen prägten auch Nellys Porträts von den zwanziger bis in die fünfziger Jahre. Franz Fiedler verwendete dagegen Mittelformatkameras und ab 1925

as the subtitle went, acted as the organ of the Beauty Movement, an association of German nature lovers and nudists. The journal was illustrated exclusively with nude photos, including studio and outdoor stills taken by Fiedler among others.[12] Thus, by 1923, Nelly was hardly alone with her photos of naked dancers. Thanks in part to its publishers, Dresden became a center, alongside Berlin, of the 1920s "free-body culture" movement, which had evolved out of the 19th-century "Wandervogel" hiking groups and later the Allied Youth movement. Free-body groups were banned by the Nazis immediately after their seizure of total power in March 1933. A few remnants of the nudist movement reorganized as the "Alliance for Physical Discipline", which was incorporated into the ideologically pure National Socialist Sporting Organization.[13]

In the 1920s, Nelly produced a long series of visceral and discerning portraits taken in both Dresden and Athens. Printed as monochromes with Bromoil coloring, these are among the outstanding photographic achievements of that era. Most are bust portraits of male or female models *en face* or in profile. Melancholy predominates. Especially the young women seem to yearn dreamily after a lost, beautiful feeling. They are more like *femme fragiles* than *femme fatales*. Every element of these pictures concentrates on the unmediated expression of the subjects. Nelly focuses on their faces and their gestures. She uses pigmentation to neutralize the background into a single-hued, unstructured simplicity. Beyond the traditional severity of studio photography, these portraits also reveal the photographer's empathic sensitivity. Yet despite the singularity of Nelly's perspective, these pictures are still a product of her era. The use of Bromoil to achieve distance places these stills on the cusp between tradition and upheaval, between individual physiognomy and emblematic type. These works from the early 1920s already reveal a surprising independence in Nelly's photographic expression.

Fiedler played a key role in the subsequent development of her visual technique. As a teacher, he was always the "helping friend, the confidante," as Helmut Grunwald wrote in a monograph on the Bohemian portrait photographers. Next to the technical details of camera work and the variety of darkroom techniques, Fiedler also taught Nelly about "how to activate visual thinking."[14] Her mentor[15] helped her devise her plans for starting a studio in Athens, and later served as her consultant on technical questions.

Fiedler bestowed a diploma on Nelly on December 15, 1923.[16] She returned to Germany in 1925 for the spring trade fair in Leipzig, where the small-format Leica was introduced. On Fiedler's advice, Nelly bought a Leica, a studio camera, and other equipment at the fair.[17] She carried this precious load from Dresden back to Athens, where she opened her own photo studio on the central thoroughfare of Ermou Street.

auch die Kleinbildkamera Leica bei seinen Freiluftaufnahmen und bewerkenswerterweise auch im Atelier für das Bildnis.[9] Nelly scheint – angeregt durch Fiedler – für ihre Aktaufnahmen in der Sächsischen Schweiz ebenfalls Kameras für ein kleineres Negativformat benutzt zu haben, mit denen ein spontaneres und schnelleres Reagieren auf die Tanzbewegungen der Modelle möglich war. 1924 wurden einige ihrer Aktaufnahmen in dem Bildband *Ideale Körper-Schönheit* des Dresdner Vitus-Verlages veröffentlicht.[10] Neben Aufnahmen von Magnus Weidemann, Lotte Herrlich, Kurt Oelzner finden sich darin auch drei Photographien von Fiedler und sechs von Nelly. Das Inhaltsverzeichnis enthält den Hinweis, daß »von allen numerierten Abbildungen Original-Lichtbilder in verschiedenen Grössen« zu erwerben seien.[11]

Vergleichbare Bücher erschienen gleichzeitig im Dresdner Verlag der Schönheit, wo seit 1904 auch die Zeitschrift *Die Schönheit* verlegt wurde. Diese ›Monatsschrift für Kunst und Leben‹, so der Untertitel, verstand sich als Organ des sogenannten Schönheitsbundes, einer Natur- und Nacktkulturvereinigung in Deutschland. Ausschließlich Aktaufnahmen, aufgenommen im Studio und im Freien, u.a. auch von Fiedler, illustrierten die Zeitschrift.[12] Nelly stand mit ihren Aufnahmen nackter Tänzerinnen um 1923 somit keineswegs allein. Dresden wurde in den zwanziger Jahren neben Berlin nicht zuletzt wegen dieser Publikationsmöglichkeiten zum Zentrum der neuen ›Freikörperkultur‹ in Deutschland, die sich aus der Bewegung der ›Wandervögel‹ und der späteren ›bündischen Jugend‹ entwickelt hatte. Sofort nach Regierungsübernahme der Nationalsozialisten wurden die deutschen FKK-Verbände im März 1933 verboten; einige ehemalige Mitglieder jedoch »reorganisierten sich als ›Bund für Leibeszucht‹ und betrieben ihre Reintegration in die gleichgeschaltete NS-Sportorganisation«.[13]

Zu den herausragenden Bildleistungen der zwanziger Jahre zählen Nellys einfühlsame Porträts aus Dresden und später aus Athen, ausgeführt als monochrom farbige Bromöldrucke. Es handelt sich meist um Brustporträts von männlichen oder weiblichen Modellen en face oder im Profil, in denen Melancholie vorherrscht. Insbesondere die jungen Frauen scheinen sehnsüchtig träumend einem vergangenen, schönen Gefühl nachzuhängen; sie entsprechen eher dem Typus der ›femme fragile‹ als der ›femme fatale‹. Alles in den Bildern ist auf den unmittelbaren Ausdruck der Porträtierten konzentriert. Nelly fokussierte ihre Gesichter und deren Mimik; den Bildhintergrund neutralisierte sie in einfarbiger, unstrukturierter Schlichtheit durch die malerischen Effekte der Edeldrucktechniken. Neben der traditionellen Strenge einer Atelierphotographie offenbaren die Porträts gleichzeitig die psychologische Sensibilität der Photographin. Doch trotz ihres individuellen Blicks sind sie Bilder dieser Zeit. Durch die photographische Verfremdung mittels Bromöldruck schwanken diese Aufnah-

Athens (1924–1939)
At the Height of Her Career

The high quality of Nelly's portraits soon gained her a reliable clientele within the Athenian society. She took pictures of the rich, the famous, and the royal. The Athenian cultural scene and foreign photographers all gathered at Nelly's portrait studio, which doubled as a gallery for her work.

She also lived right next door, until 1930. The first studio room measured a mere ten square meters. Bust portraits were no problem, but for a full-length shot she was forced to open the door and place the camera in the next room. She later moved to a location three times the size, where she could also take group portraits.[18]

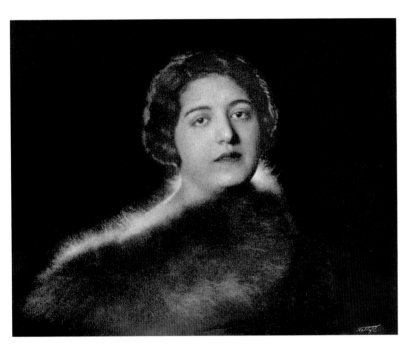

Portrait of a woman, early 1920s
Frauenporträt, frühe 20er Jahre

Nelly created the main body of her work during the late 1920s and early 1930s in Greece, above all in her chosen home, Athens. Social change and women's emancipation moved at a much slower pace in tradition-conscious Greece than in the progressive Germany of the 1920s. Expressive dance, which Nelly had learned and eagerly documented in Dresden through Mary Wigman and her school, did not catch on in Greece.[19] Unsurprisingly, conservative circles met the unsolicited publication of Nelly's photographs of a naked dancer on the Acropolis in the French journal Illustration in 1929 with a storm of indignation. But with help from the influential Athenian writer Pavlos Nirvanas, who attacked the bigotry and puritanism of Nelly's critics in a newspaper column, she achieved a sort of rehabilita-

men zwischen Tradition und Aufbruch, zwischen individueller Physiognomie und Typus. Bereits in diesen Werken aus den frühen zwanziger Jahren ist eine überraschende Eigenständigkeit ihrer photographischen Ausdrucksweise zu konstatieren.

Für die weitere Entwicklung ihrer Bildsprache ist Fiedler von besonderer Bedeutung. Als Lehrer blieb er stets der »helfende Freund, der Vertraute«, so Helmut Grunwald in einer Monographie über den böhmischen Porträtphotographen. Fiedler vermittelte Nelly neben technischen Details der Kamera und unterschiedlichen Bearbeitungsmöglichkeiten in der Dunkelkammer auch die »Aktivierung des bildnerischen Denkens«.[14] Ihr Mentor[15] beriet sie auch im Hinblick auf die bevorstehende Studiogründung in Athen und später in allgemeinen technischen Fragen.

Am 15. Dezember 1923 beendete sie ihre Ausbildung bei Fiedler mit einem Diplom.[16] 1925 besuchte sie die Leipziger Frühjahrsmesse, wo die Kleinbildkamera Leica präsentiert wurde. Auf Fiedlers Rat erwarb sie dort neben anderen Ausrüstungsgegenständen eine Studiokamera und eine Leica.[17] Mit dieser kostbaren Ausrüstung im Gepäck reiste sie von Dresden nach Athen und eröffnete in der im Stadtzentrum gelegenen Ermou-Straße ihr eigenes Photostudio.

Athen (1924–1939)
Auf dem Höhepunkt ihrer Karriere

Die Qualität ihrer Bildnisse verschaffte ihr schnell einen festen Kundenkreis innerhalb der Athener Gesellschaft, sie photographierte die Schönen, die Reichen und die königliche Familie. Nellys Porträtstudio, in dem sie ihre Bilder auch ausstellte, entwickelte sich nicht nur zu einem Treffpunkt der Athener Kulturszene, sondern wurde auch für viele auswärtige Photographen zu einem Forum.

Ihr erster Atelierraum, neben dem sie bis 1930 auch wohnte, war nur etwa 10 Quadratmeter groß. Brustporträts waren zwar problemlos möglich, für Ganzkörperaufnahmen mußte sie allerdings durch die geöffnete Tür aus dem Nebenraum photographieren. In ihrem zweiten, etwa 30 Quadratmeter großen Studio konnte sie auch Gruppen porträtieren.[18]

Nellys Hauptwerk entstand in den späten zwanziger und frühen dreißiger Jahren in Griechenland, insbesondere in ihrer Wahlheimat Athen. Die Veränderung der gesellschaftlichen Verhältnisse, die Emanzipation der Frau schritt im traditionsbewußten Griechenland weniger schnell voran als im progressiven Deutschland der zwanziger Jahre. Auch der Ausdruckstanz, den Nelly in Dresden über Mary Wigman und ihre Schülerinnen kennenlernte und neugierig dokumentierte, hielt keinen Einzug in Griechenland.[19] So war die Empörung konservativer Kreise nach der ungewollten Veröffentlichung von Nellys Photographien einer nackten Tänzerin auf der Akropolis in

tion.[20] The dispute over the supposed desecration of ancient and once-holy sites, and the manner of its resolution made Nelly known beyond the borders of Greece. Two years later, she returned to the Acropolis for a repeat performance. The first series of dance nudes had featured Mona Paiva; in the second, the ballerina Nikolska, clad only in a transparent veil, danced between the columns of the Parthenon. Having seen the earlier photos of Paiva, a thrilled Nikolska begged Nelly to do a similar series with her. One of the Nikolska stills appeared on the cover of the French magazine Voilà in 1934.[21] Nelly's series of Mona Paiva and Nikolska are without a doubt among the highlights of 1920s dance photography.

Nelly's dance photos derived both from her careful studio poses and her spontaneous spot stills with very quick shutter times. The size of her glass and roll film negatives (9 x 12cm) is surprising, since the dynamism of the shooting suggests a handier camera, a Leica or a Rolleiflex with a correspondingly smaller negative format. The results are static motion studies of actresses and dancers.

The basic problem in dance photography is how to translate dynamic dance into a static picture, how to condense a complex series of motions into a single shot. Lacking our present-day possibilities for automatic film transport, the dance photographers in the early days had to capture motion in discrete stills. Good results demanded technical perfection, a thorough knowledge of dance, and an instinct for anticipating motion. One possibility was to have the dancers hold a pose for the camera, as Isodora Duncan did in Elvira's studio and as Ellen Tell did in d'Ora's.[22] Other German studio photographers, like Charlotte Rudolph and Hugo Erfurth, took snapshots of dancers in motion. Erfurth was the first to have actual dancing in his studio, in 1908, thus becoming "the creator of a new genre, true dance photography."[23] His series of pictures of the dancer Clotilde von Derp four years later qualified him as "the first documentarist of early expressive dance."[24] Nelly followed her teacher into this genre in 1923, although dance photography had played no role in her training. She first encountered nude photography and stills of moving subjects at Fiedler's. This manner of dance photography was completely unknown in Greece. Thus Nelly's extraordinary images of Mona Paiva in 1927 and of Nikolska in 1929 opened a new chapter in the history of Greek photographic art.

Atop the Acropolis, Nikolska leaps and is captured by Nelly in a moment of great physical tension. Nikolska seems to hover within the frame. Almost in profile, her half-naked body is stretched to the extreme. Her left arm and left leg extend to the rear, her right arm thrusts up into the air and the right leg down to the ground. Nothing about the motif suggests a pose. Nelly seems to have been perfectly in tune with the choreography as she followed the steps intuitively with her camera.

The photo of a leap gives rise to a tense relation between the body and its surroundings. The slender dancer and the thin,

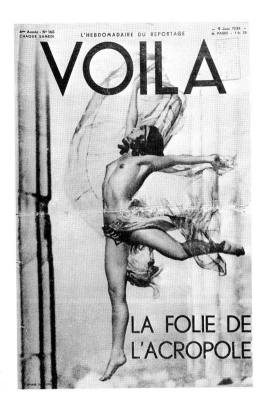

Cover of the weekly periodical *VOILA*, 1934
Titelblatt der Wochenzeitschrift *VOILA*, 1934

dem französischen Journal *Illustration* 1929 nur zu verständlich. Doch mit Hilfe des einflußreichen Athener Kolumnisten und Schriftsteller Pavlos Nirvanas, der in einem Zeitungsartikel wiederum die bigotten, puritanischen Kritiker von Nelly angriff, konnte sich die Photographin gewissermaßen rehabilitieren.[20] Der Streit um die vermeintliche Entweihung der antiken, ehemals heiligen Stätte und die Art seiner Schlichtung machte Nelly über die Grenzen Griechenlands hinaus bekannt. Zwei Jahre später entstand eine weitere Photoserie auf der Akropolis: Nach Mona Paiva tanzte nun die Ballerina Nikolska zwischen den Säulen des Parthenon, bekleidet nur mit einem transparenten Schleier. Nikolska hatte die publizierten Bilder ihrer Kollegin gesehen und bat Nelly begeistert, sie innerhalb des Parthenon in ähnlichen Tanzposen zu photographieren. 1934 wurde abermals eine Aufnahme als Titelbild des französischen Magazins *Voilà* publiziert.[21] Nellys Bildserien von Mona Paiva und Nikolska gehören zweifellos zu den wichtigsten Tanzphotographien der zwanziger Jahre.

Ihren Tanzbildern liegen einstudierte Atelierposen und andererseits spontane Momentaufnahmen mit sehr kurzen Verschlußzeiten des Kameraobjektivs zugrunde. Die Größe der von Nelly verwendeten Glas- und Rollfilmnegative (9 x 12 cm) überrascht, da die Dynamik der Situation eine handlichere Kamera, beispielsweise eine Leica oder Rolleiflex, und somit ein kleineres Negativformat vermuten ließe. Es entstanden statische Bewegungsstudien von Schauspielerinnen und Tänze-

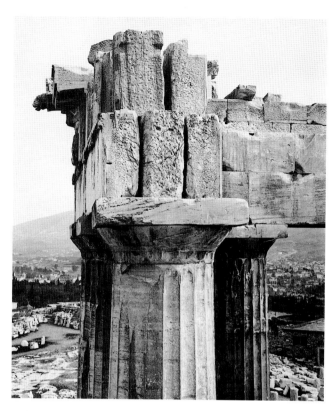

Walter Hege, Entablature on the Parthenon / Gebälk des Parthenon,
1928/29, Agfa Foto-Historama, Cologne / Köln

transparent fabric that billows around her as she jumps clash
with the thick-set columns of the temple and their hardness.
The erstwhile holy site becomes a background motif, a monu-
mental stage set.

This photographic performance was only conceivable given
Nelly's intensive study of the new forms of dance during her
artistic schooling in Dresden.

Nelly moved beyond dance photography and portraiture
starting in the mid-1920s, at first on her own initiative but later
at the Greek government's expense. She took countless photo-
graphs of landscapes, towns, villages, and archaeological digs
throughout Greece: temple ruins, sculptures, ancient fortifica-
tions, theaters. Nelly's photographic record of the Survival of
the Classics remained on a conventional level, at least in com-
parison to her dance photography. Aside from a few close views
of architectural details, such as of the caryatids of the
Erechtheum on the Athenian Acropolis, as a matter of principle
she took reserved and objective frontal views of ancient build-
ings like the Parthenon, the Erechtheum, and the Propylaeum
at the entrance of the Acropolis. The unusual touch for archi-
tectural photography at the time is found in her use of pigmen-
tation techniques, with which she infused a new vitality into
the ancient buildings. Nelly shot the decorative frieze atop the
cella of the Parthenon from below ground level, consciously

rinnen. In der Tanzphotographie besteht grundsätzlich das
Problem, den dynamischen Tanz in ein statisches Bild zu über-
setzen und somit einen komplexen Bewegungsablauf in einer
einzigen Aufnahme zu verdichten. In der Frühzeit arbeiteten
die Tanzphotographen ohne die heutigen Möglichkeiten des
automatischen Bildtransports in Einzelbildserien. Kameratech-
nische Perfektion, fundierte Tanzkenntnisse und ein Gespür für
die kommende Bewegung waren Voraussetzungen für zufrieden-
stellende Bildergebnisse. So entstanden auch in diesem Sujet
Posen der Tänzerinnen für den Kamerablick, wie sie etwa das
Atelier Elvira von Isadora Duncan oder das Atelier d'Ora von
Ellen Tells festhielt.[22] In anderen deutschen Ateliers, etwa
jenem von Charlotte Rudolph oder auch von Nellys Lehrer
Hugo Erfurth, wurden Bewegungsfolgen als Momentaufnah-
men photographiert. Erfurth holte 1908 als erster Lichtbildner
den Tanz »ins Atelier« und wurde so »zum Schöpfer einer
neuen Gattung, der eigentlichen Tanzphotographie«.[23] Vier
Jahre später avancierte er mit den Bildserien von Clotilde von
Derp zum »ersten Dokumentaristen des frühen Ausdruckstan-
zes«.[24] Nelly folgte ihrem Lehrer ab 1923 somit auch innerhalb
dieser Gattung, ohne daß sie Bestandteil ihrer Ausbildung bei
Erfurth gewesen war. Erst bei Fiedler begegnete sie der Aktpho-
tographie und der bewegten Momentaufnahme. In Griechen-
land entstanden zur selben Zeit keine vergleichbaren Tanz-
photographien. Nelly hat so mit ihren außergewöhnlichen
Bildserien von Mona Paiva und Nikolska 1927 und 1929 ein
neues Kapitel in der griechischen Photographiegeschichte
geschrieben.

Die Sprünge, die Nikolska auf der Akropolis vollführte,
sind auf Nellys Photo in einem Moment höchster Körperspan-
nung eingefangen. Sie scheint auf dem Bild zu schweben.
Nikolska wurde im leichten Profil aufgenommen und streckt
ihren halbnackten Körper aufs Äußerste. Ihr linker Arm und
ihr linkes Bein sind nach hinten gestreckt, ihr rechter Arm in
die Höhe und das rechte Bein zum Boden. Nelly schien die
Choreographie dieses keineswegs wie eine Pose wirkenden
Tanzmotivs zu kennen oder die tänzerischen Sprünge intuitiv
mit ihrer Kamera zu begleiten.

In der Darstellung des Sprunges entsteht ein spannungsvol-
les Verhältnis des Körpers zur Umgebung: Die Schlankheit der
Tänzerin und der dünne, durchsichtige Stoff, den sie im Sprung
bauschen ließ, kontrastieren mit den gedrungenen Säulen des
Tempels und der Härte ihres Materials. Die ehemals heilige
Stätte wird zum Hintergrundmotiv, zur monumentalen Thea-
terkulisse.

Diese photographischen Inszenierungen waren nur denk-
bar, weil sich Nelly bereits während ihrer Ausbildungszeit in
Dresden intensiv mit neuen Bewegungsformen des Tanzes aus-
einandergesetzt hatte.

Neben ihren Tanzphotographien und Porträts entstanden
seit Mitte der zwanziger Jahre, zunächst ohne Auftrag, später

presenting it from the perspective of a normal visitor to the Acropolis. This role-playing distinguishes her work from the photographic eye of a Walter Hege, who saw only the archaeological context and presented monumentalized Greek temple architecture and sculpture. Like Fred Boissonnas before him, Hege erected a scaffolding around the Parthenon and set about systematically photographing its reliefs, plate for plate, with very near details of entablatures. Hege thus set different standards than Nelly for photography in Greece in the late 1920s.

The architectural photographs taken in Greece by the German Survey Agency at the beginning of the 20th century were meant to serve as informative media in the cause of restoring deteriorating artistic landmarks. Only today do we also see their artistic value. In 1910, the Greek government commissioned the Survey Agency to systematically document the ancient temples and Byzantine churches of Greece in large-format pictures. These were presented a year later at the World Fair in Rome. In its nearly complete record of Greek monuments, the German institution, led by Alfred Meydenbauer, was in a sense the direct predecessor to Nelly, who took on a similar task in the early 1930s on behalf of the Greek Ministry of Tourism.[25]

Nelly's passions for Greece and its classical past were originally stirred by her father's stories to her as a child. But she first saw Athens at the age of twenty-five. "As soon as I was in Greece, I visited the Acropolis," she later recalled, underlining her yearning for an unmediated view of antique architecture.[26] This personal devotion underlay her photographic documentations of classical Athens and of the original architecture of the Plaka district with its many medieval constructions. She took many photographs of the Plaka in the late 1920s, developing these as Bromoil prints and presenting a selection of sixty-five stills in her studio.[27] None of the foreign photographers circulating Athens at the time had ever thought of photographing the Plaka. Nelly's great sensitivity defines the atmosphere in her pictures of Greek refugees from Asia Minor. Taken in Athens in 1925, they show people who had suffered the same fate as her own family, who had been driven from their homes and into poverty. Nelly exhibited Bromoil prints of the migrants at her studio in 1926 under the title: "The Sorrows of the Refugees."

She took photo tours of the Peloponese in the mid-1920s with the Swiss photographer Fred Boissonnas[28] and developed his glass negatives in her darkroom, as she had done before on behalf of Erfurth and Fiedler in Dresden. Nelly ultimately adopted Boissonnas' systematic approach in her own landscape photography.[29] He had undertaken comprehensive documentary surveys of Athens between 1903 and 1919. His photographic approach to the Acropolis in 1907—beginning with many shots from the distance and the climb up to the Propylaeum and ending with views of the Athenian surroundings from the top of the promontory—was mimicked by Nelly in a similar series in the late 1920s. Boissonnas' sets were the first to provide a full visual

für die griechische Regierung, zahlreiche Aufnahmen von Landschaften und Städten sowie der archäologischen Ausgrabungen in ganz Griechenland: Tempelruinen, Skulpturen, antike Festungsanlagen oder Theater. Doch Nellys photographische Antikenrezeption blieb – im Gegensatz zu den Tanzbildern – eher konventionell. Neben einigen Nahansichten von Architekturdetails, etwa der Koren des Erechtheion, versuchte sie grundsätzlich, die Hauptansicht der antiken Gebäude, etwa des Parthenon, des Erechtheion oder der Propyläen auf der Athener Akropolis, zurückhaltend und sachlich in Szene zu setzen. Doch ungewöhnlich für die Zeit bleibt Nellys Verwendung von Edeldrucktechniken auch in der Architekturphotographie, durch die sie der antiken Baukunst eine neue Sinnlichkeit verliehen hat. Den Cellafries des Parthenon photographierte Nelly in Untersicht vom Bodenniveau des Burgberges und präsentierte ihn somit bewußt aus dem Blickwinkel eines normalen Akropolisbesuchers. Dieses Rollenspiel unterscheidet ihre Arbeit vom photographischen Blick eines Walter Hege auf die griechische Tempelarchitektur und die Bauskulptur, der diese ausschließlich im archäologischen Kontext sah und monumentalisierte. Für die systematische photographische Dokumentation des Parthenonfrieses ließ er – wie Fred Boissonnas vor ihm – ein Gerüst errichten, um die antiken Reliefs Platte für Platte oder auch Teile des Gebälks in Nahansicht zu photographieren. So setzte Hege Ende der zwanziger Jahre für die Photographie in Griechenland andere Standards als Nelly.

Die Architekturaufnahmen der Staatlich-Preußischen Meßbildanstalt aus Griechenland um die Jahrhundertwende dienten ursprünglich als bloße Informationsträger für Bauforscher und Denkmalschützer im Hinblick auf eine mögliche

The west gable of the Parthenon, c. 1930
Westgiebel des Parthenon, um 1930

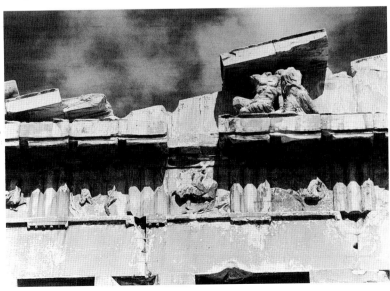

treatment of Athens and the Acropolis to people who had never been there. They belong to "the most important chapter of Greek photography, before its division into separate currents of artistic interpretation, pictoresque standard views, and ideologically hardened ways of seeing." [30]

In 1929 in Athens Nelly married the Greek pianist Angelos Seraidaris, whom she had met in Dresden and who later occasionally took photos on her behalf (and in her name), as for example on Mount Athos, the Greek Orthodox holy peninsula which is closed to women. [31] In his portrayal of the humble life of monks, the monastery architecture and landscape around Mount Athos, Seraidaris was factual, reserved and only mildly stylized.

Nelly was hired as the exclusive photographer of the second Delphic Games in 1930. She took portraits of the actors on the ancient theater stage and in the cliffs around Delphi, sometimes in the presence of an audience, sometimes at a provisional outdoor studio. She arranged a few of the group portraits as tableaux vivants, as though set in a Grecian gable frieze. These photos reveal the roots of modern expressive dance in the classically inspired poses of actors. Nelly thus combined the two subjects that were dominant within her work until then: portraiture and dance photography.

In 1936 Nelly traveled once again to Germany, where, in the town of Hemelingen, Johannes Herzog introduced her to the Duxochrome color process, which he had developed in 1929 on the basis of photographic copying. The combination of a Bermpohl natural-color camera (named after its inventor, the Berlin camera maker Wilhelm Bermpohl) and the Duxochrome process created results of unusually high quality for that time. [32] By the time Nelly returned to Greece from this latest pilgrimage, she carried with her a hand-made and rather exorbitantly priced Bermpohl camera. She thus introduced color photography to Greece. She made portraits of King George II and assorted Greek luminaries with the three-color camera in Duxochrome, and later switched to the Carbro print process. [33] Her color films of the Olympic Games in Berlin, however, were apparently confiscated from the film developer by the Gestapo in 1936; at any rate, they can no longer be found. [34]

In Nelly's work we see a logical development from experimentation with print and pigmentation techniques in the 1920s to real color photography in the 1930s. Her conscious use of Bromoil, a darkroom relic from the era of pictorialist photography around the turn of the century, [35] hinted at a certain degree of traditionalism. But Nelly expanded colorization in the print process to a form of free photo painting, reducing certain photographs to pure motif and transforming them into assuredly singular color drawings. This media synthesis of painting and photography, inspired by her painting lessons with Simonson-Castelli, was without parallel in the mid-1920s, in either Dresden or Athens.

20

Restaurierung verfallener Kunstdenkmäler; inzwischen wird auch diesen Bildern ein künstlerischer Wert beigemessen. Die Meßbildanstalt wurde 1910 von der griechischen Regierung beauftragt, in Griechenland systematisch antike Tempel und byzantinische Kirchen in großformatigen Bildern zu dokumentieren, die ein Jahr später auf der Weltausstellung in Rom präsentiert wurden. Insofern ist die deutsche Institution um Alfred Meydenbauer in der beinahe lückenlosen Erfassung griechischer Baudenkmäler unmittelbarer Vorgänger von Nelly, die Anfang der dreißiger Jahre einen ähnlichen Auftrag der griechischen Presse- und Tourismusbehörde ausführte. [25]

Die Leidenschaft für Griechenland und seine klassische Vergangenheit begleitete Nelly seit ihrer Jugend, ausgelöst durch die Erzählungen ihres Vaters. Doch sie kam erst mit 25 Jahren nach Athen. »Sobald ich in Griechenland war, besuchte ich die Akropolis«, erinnerte sie sich später und unterstrich so ihre Sehnsucht nach unmittelbarer Anschauung der antiken Architektur. [26] Eine persönliche Verbundenheit motivierte ihre photographische Dokumentation des klassischen Athen sowie der ursprünglichen Architektur in der Plaka. Von den teilweise mittelalterlichen Bauten entstand Ende der zwanziger Jahre eine umfangreiche Bildserie als Bromöldrucke, von denen sie 65 Aufnahmen in ihrem Studio präsentierte. [27] Diesem Motiv hatte sich keiner der zahlreichen ausländischen Photographen, die in Athen weilten, zuvor gestellt. Nellys persönliche Anteilnahme bestimmt auch die Atmosphäre der Bilder der griechischen Flüchtlinge aus Kleinasien, die sie um 1925 in Athen photographierte und die das gleiche Schicksal traf wie ihre eigene Familie nach deren Vertreibung. Die Bromöldrucke der Migranten zeigte Nelly 1926 unter dem Titel ›The Sorrows of the Refugees‹ ebenfalls in ihrem Studio.

Parallel arbeitete Nelly Mitte der zwanziger Jahre gemeinsam mit dem Schweizer Photographen Fred Boissonnas [28] auf der Peloponnes und entwickelte dessen Glasnegative in der Dunkelkammer, wie zuvor in Dresden diejenigen ihrer Lehrer Erfurth und Fiedler. Nelly orientierte sich später bei ihren eigenen Landschaftsaufnahmen an der Systematik von Boissonnas' Bildserien. [29] Dieser führte bereits zwischen 1903 und 1919 umfangreiche Dokumentationen in Athen durch. Auch seine photographische Annäherung an die Akropolis im Jahr 1907 mit zahlreichen Einzelaufnahmen aus der Entfernung, des Aufgangs zu den Propyläen sowie die Blicke zurück auf die landschaftliche Umgebung Athens wurde – leicht reduziert und variiert – Ende der zwanziger Jahre von Nelly übernommen. Seine Photoserien ermöglichten es dem zeitgenössischen Bildbetrachter erstmals, sich die Stadt Athen und die Akropolis sukzessiv visuell zu erschließen. Boissonnas' Bilder gehören zum »bedeutendsten Kapitel der Griechenlandphotographie, bevor diese sich in weitergehende künstlerische Interpretationen, pittoreske Standardansichten und ideologisch verhärtete Sichtweisen differenzierte.« [30]

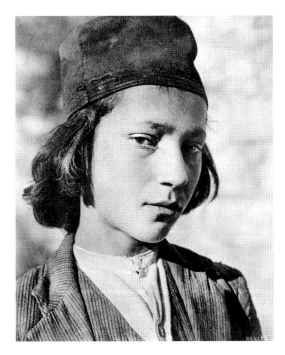

Angelos Seraidaris, Portrait of a novice / Porträt eines
Novizen, Athos, 1935

The severe cropping she employed in her early portraits was
typical of photography in general. Beyond the traditional por-
trait photographers like Hugo Erfurth and Franz Grainer, others
expanded the genre of portraiture in the late 1920s and early
1930s with photographically fragmented faces, as in the case of
Max Burchartz, or with radical super-close-ups of heads, like
Helmar Lerski. Stylized experiments of this type were of no con-
cern to Nelly. In Athens, she did portraits "very much in
Erfurth's vein of prominent artists, musicians and writers."[36] In
her studio portraits she continued developing the visual tech-
niques she had learned in Dresden, but there was a bottom line:
she had to serve the conservative tastes of the Athenian *grandes
dames*. Nelly thus combined the old with the new, fusing
conventionalism and innovation into her own characteristic
language.

Nelly made a portrait in 1925 of the popular Greek sports-
man Karabatis as a sensuous and contemplative man, posing in
front of the Acropolis.[37] Here, monumental architecture
becomes a vivid background motif for the half-naked athlete.
Print pigmentation is employed to establish distance to the
body, the sky and the stone architecture, all of which seem
drawn in large grains. But the photos possess authenticity inso-
far as Nelly, like the French *plein-air* painters some decades
before her, really did go into nature, in this case climbing the
Athenian temple mount. At the same time, her earthy portraits
of athletes—a sort of preparation for the later dance pictures in
the same location—seem historically timeless.[38]

In Athen heiratete Nelly 1929 den griechischen Pianisten
Angelos Seraidaris, den sie in Dresden kennengelernt hatte
und der später gelegentlich in ihrem Auftrag und unter ihrem
Namen photographierte, etwa auf dem Berg Athos, der Nelly
als Frau nicht zugänglich war. Seine Aufnahmen, lange Zeit
Nellys Werk zugeschrieben, wie beispielsweise das bekannte
Porträt eines Novizen, wurden 1995 vom Athener Benaki-
Museum aufgearbeitet und publiziert.[31] Seraidaris schilderte das
bescheidene Leben der Mönche, die Klosterarchitektur und
die Landschaft auf dem Berg Athos sachlich, zurückhaltend
und gelegentlich etwas stilisierend.

Das zweite Delphi-Festival sah Nelly 1930 als Exklusivre-
porterin. Sie porträtierte die Schauspieler auf der antiken
Theaterbühne, in der Felslandschaft um Delphi, im Zuschauer-
rund oder im provisorischen Studio. Einige Gruppenporträts
arrangierte Nelly nach klassischen Giebelfiguren als ›tableaux
vivants‹. Die klassisch inspirierten Posen der Schauspieler wer-
den als Quelle der modernen Bewegungsmuster im Ausdrucks-
tanz offenbar. Hier verband Nelly die beiden Sujets, die ihr
Werk in den Jahren zuvor bestimmt hatten: Porträt- und Tanz-
photographie.

1936 reiste Nelly ein weiteres Mal nach Deutschland, um
sich in Hemelingen von Johannes Herzog in das von ihm 1929
neu entwickelte Duxochrom-Farbverfahren einführen zu las-
sen, das auf einem photographischen Kopierprozeß beruht. Die
Kombination einer Bermpohl-Naturfarbenkamera, benannt
nach seinem Erfinder, dem Berliner Kameratischler Wilhelm
Bermpohl, und dem Duxochrom-Verfahren führte damals zu
den besten photographischen Ergebnissen.[32] Als Nelly nach
Griechenland zurückkehrte, hatte sie die handgefertigte, sehr
kostspielige Bermpohl-Kamera im Gepäck. Damit führte sie die
Farbphotographie in Griechenland ein. So porträtierte sie
König Georg ii. sowie Mitglieder der griechischen Gesellschaft
mit der Dreifarbenkamera in Duxochrom und später im Car-
brodruck-Verfahren.[33] Ihre Farbaufnahmen der Olympischen
Spiele in Berlin wurden bei der Entwicklung 1936 möglicher-
weise von der Gestapo beschlagnahmt und gingen verloren.[34]

Die Entwicklung im Werk von Nelly von der Beschäftigung
mit den Edeldrucken und deren Kolorierung in den zwanziger
Jahren zur Farbphotographie in den dreißiger Jahren erscheint
konsequent. Der bewußte Rückgriff auf den Bromöldruck, eine
Dunkelkammertechnik aus der Zeit der piktorialistischen
Photographie um die Jahrhundertwende,[35] stellte zwar einen
gewissen Traditionalismus dar. Doch die Kolorierung der Edel-
drucke erweiterte Nelly bis zu freien Photomalereien, wobei
einige Photographien auf einen bloßen motivischen Ausgangs-
punkt reduziert und in eine farbige Zeichnung und damit in ein
Unikat verwandelt wurden. Diese mediale Synthese von Male-
rei und Photographie, angeregt durch ihren Malereiunterricht
bei Simonson-Castelli, blieb Mitte der zwanziger Jahre in Dres-
den und Athen ohne Vergleich.

Nelly's portraits and dance photographs on the Acropolis of 1925, 1927, and 1929 do not stand alone. An immediate predecessor was Edward Steichen with his photos of Isadora Duncan between the columns of the Parthenon in 1921—which Nelly says she only saw long after making her own shots of Paiva and Nikolska.

Meeting Steichen in Venice, Duncan persuaded him to follow her to Greece with the promise that she would dance for him and his camera before the classical setting. But when they got there she refused to deliver, saying that her dance should be remembered exclusively "from legend." Steichen said later that she was only willing to pose as a statue.[39] Isadora Duncan felt incapable of dancing on the Acropolis, saying she would feel "like an intruder, like a troublemaker." "Her entire dance art was inspired by Greek temple friezes and by Greek vase paintings. She herself was a piece of Greece, and she viewed Greece as a part of herself." Steichen took pictures of Duncan in the Parthenon, standing at the end of a row of columns, her arms raised up in the air, "in full harmony with the columns." Luckily, an accompanying group of "Isadorables" (as the students from Duncan's school were called) had no compunctions whatsoever about dancing freely in front of Steichen's camera. He described

Actress at the Delphic festival, 1930
Schauspielerin der Delphischen Festspiele, 1930

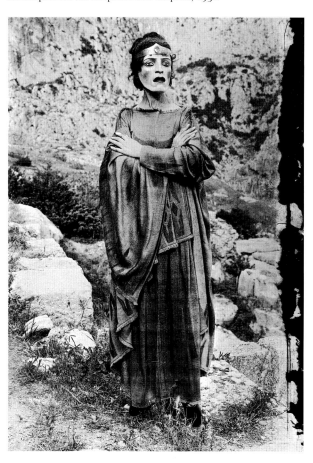

Der strenge Bildausschnitt, den Nelly bei ihren frühen Porträts wählte, war ein Merkmal der zeitgenössischen Photographie. Neben traditionellen Bildnisphotographen wie Hugo Erfurth oder Franz Grainer erweiterten andere Kollegen in den späten zwanziger und frühen dreißiger Jahren die Gattung Porträt mit photographisch fragmentierten Gesichtern wie Max Burchartz oder Helmar Lerski mit radikal nahansichtigen Köpfen. Solche stilistischen Versuche beschäftigten Nelly nicht; sie porträtierte in Athen vielmehr »nach dem Vorbild Erfurths ebenfalls prominente Künstler, Musiker und Schriftsteller«.[36] In ihren Studioporträts führte sie die in Dresden erlernte Bildnistechnik weiter, bediente aber auch den konservativen Bildgeschmack der weiblichen Athener Gesellschaft. So verband Nelly Altes und Neues, Konventionelles und Innovatives zu einer charakteristischen Bildsprache.

Bereits 1925 hatte Nelly den damals populären griechischen Sportler Karabatis als sinnlichen und kontemplativen Mann porträtiert. Er posiert vor der Athener Akropolis.[37] Die Monumentalarchitektur wird zu einem sprechenden Hintergrundmotiv für den halbnackten Athleten. Verfremdet durch ein Edeldruckverfahren wirken Körper, Himmel und Steinarchitektur im groben Korn wie gezeichnet. Auf den ersten Blick ist kaum ein Unterschied zur Atelierphotographie mit den damals noch üblichen austauschbaren Bildhintergründen auszumachen. Doch gerade weil Nelly – wie die französischen Freiluftmaler einige Jahrzehnte zuvor – tatsächlich in die Natur, hier konkret auf den Athener Tempelberg stieg, besitzen die Aufnahmen einen Zugewinn an Authentizität. Gleichzeitig wirken ihre sinnlichen Sportlerporträts, die die nackte Körperlichkeit in den Tanzbildern am gleichen Ort inhaltlich vorbereiteten, historisierend zeitlos.[38]

Doch Nellys Porträts und Tanzphotographien auf der Akropolis von 1925, 1927 und 1929 stehen nicht allein. Ein unmittelbarer Vorläufer war Edward Steichen mit seinen Aufnahmen von Isadora Duncan zwischen den Parthenonsäulen aus dem Jahr 1921, die Nelly nach eigener Aussage jedoch erst später kennenlernte. Duncan überredete Steichen in Venedig zu einem kurzen Griechenlandaufenthalt mit dem Versprechen, für ihn und seine Kamera vor der klassischen Kulisse zu tanzen. Doch vor Ort erfüllte sie dieses nicht, da man sich ihres Tanzes ausschließlich »als Legende« erinnern sollte. Allein für einige Standbilder wollte sie posieren, so Steichen später.[39] Isadora Duncan fühlte sich außerstande, auf der Akropolis zu tanzen, da sie sich »wie ein Eindringling, wie ein Störenfried« vorkäme. »Ihre ganze Tanzkunst war von den griechischen Tempelfriesen und von den griechischen Vasenzeichnungen inspiriert. Sie selber war ein Stück Griechenland, und sie betrachtete Griechenland als ein Stück ihrer selbst.« So photographierte Steichen die Tänzerin, als sie am Ende des Säulenganges des Parthenon ihre Arme hob, »in vollkommenem Einklang mit den Säulen«. Ihre mitgereisten Schülerinnen, die

one of them, Thérèse, as "the living incarnation of a Greek nymph."[40] So great was the impact on this American photographer of the Acropolis dance shots that in his autobiography he devoted a whole chapter to them, and to his brief visit to Greece with Duncan.

Despite the scandal caused by her nudes, Nelly became the official photographer of the Greek Ministry of Tourism. In this function she systematically recorded the artistic treasures and landscapes of Greece, as well as popular folklore like the *evzones*—the bodyguards of the Greek king in their traditional red and white uniforms with skirts and tassels. Most of these commissioned works lacked the originality and controversy of her earlier photos. But this period, in the 1930s, represented the high point of Nelly's career success.

New York (1939–1966)
Forced to Start Again

Nelly received a commission in early 1939 to decorate the interior of the Greek pavilion at the World Fair in the United States. She created four monumental photomontages for its walls, using montage and collage techniques for the first time in her career and combining her various œuvres: landscape and portraits together with photos of architecture and ancient sites. The works were experimental in form and conventional in content. They also served as her personal response to the then-burning question of whether modern Greeks descended from ancient Greeks—or if the various peoples under Ottoman rule became mixed during the 400 years of Turkish occupation, as German historian Jacob Philipp Fallmerayer had claimed, triggering a storm of indignation among his contemporaries.[41]

In a patriotically inspired photomontage, Nelly attempted to distinguish a physiognomic type that could be dated back through the thousands of years of Greek history. The other collages simply showed the country's natural and architectural beauty. But Greece did not play a prominent political or cultural role in the troubled Europe of 1939. Within the modern, technologically obsessed context of the World Fair in New York, Nelly's montages amounted to a romantic look back on an idealized past.

The outbreak of the war took Nelly and her husband by surprise, and they decided to stay in New York for the duration. News of the war in Europe evoked painful recollections of the expulsion of the Greeks from Asia Minor.

The new beginning forced on them in New York was difficult. But the Seraidaris' made arrangements in their new country with help from the local Greek community. They soon broke in, showing their photos of Greece at the Greek embassy in Washington, D.C. and at galleries in New York City. A few months later, Nelly's photo of a Greek soldier in traditional

King George II of Greece, c. 1937
Der griechische König Georg II., um 1937

sogenannten Isadorables, insbesondere Thérèse, »die lebendige Inkarnation einer griechischen Nymphe«,[40] tanzten dagegen ungeniert vor Steichens Kamera. Seine Tanzaufnahmen von der Akropolis waren dem amerikanischen Photographen so wichtig, daß er ihnen und der kurzen Griechenlandreise in seiner Autobiographie ein eigenes Kapitel widmete.

Trotz des Skandals um ihre Aktbilder wurde Nelly zur offiziellen Photographin der griechischen Presse- und Tourismusbehörde ernannt. In dieser Funktion dokumentierte sie systematisch die Kunstschätze und Landschaften Griechenlands sowie Volkstümliches wie die Evzoni, die Leibgarde des griechischen Königs, in ihren traditionellen Schmuck-Uniformen. Die meisten dieser Auftragsarbeiten hatten indes die Originalität und Brisanz ihrer früheren Aufnahmen verloren. Gleichwohl befand sich Nelly in den dreißiger Jahren auf dem Höhepunkt ihrer Karriere.

New York (1939–1966)
Ein erzwungener Neuanfang

Anfang 1939 erhielt Nelly den Auftrag, auf der Weltausstellung in New York die Innendekorationen des griechischen Pavillons zu gestalten: Vier monumentale Photomontagen schmückten dessen Wände. Sie arbeitete erstmals mit der Collage- und Montagetechnik und kombinierte eigene Land-

The Greek pavilion at the World Fair in New York, 1939
Griechischer Pavillon auf der Weltausstellung New York 1939

dress with the Athenian Olympieion in the background appeared on the cover of *Life*.[42] In 1947 the magazine published a set of photos in which Nelly once again attempted to demonstrate the similarities between contemporary and ancient Greek culture and define a Greek typology. When Greece was attacked by Italy in October 1940, and then occupied by German forces in the spring of 1941, Nelly did what she could to help her country with publications, lectures and by organizing charity events, in effect advancing to an "unofficial Greek ambassador to the United States." She was joined in the Hellenic Aid Campaign by a fellow photographer, the Baltic-American George Hoyningen-Huene, who in the 1930s had also undertaken several photo tours of Greece. Proceeds from his *Hellas*, an illustrated collection published in New York in 1943, went to the cause of aiding Greece.[43] Meanwhile, back in Greece, Nelly's fellow photographer Voula Papaioannou also used the means at her disposal to combat the German occupation. She photographed the exhausted and wounded soldiers returning home, and later took pictures of refugees and hungry children in the streets of Athens.[44]

Papaionnou's unmediated observations during World War II and the subsequent Greek Civil War followed the ideals of "straight photography"; by comparison, Nelly's arranged group portraits of Greek refugees from Asia Minor in the late 1920s feel more like the sacral motifs in the paintings of Raphael and Pontormo.

In New York, Nelly served as the photographer of events large and small within the Greek community. She took portraits of well-known Greeks who lived in or traveled to the city. But she did not reach the levels of her earlier visual works. So devoted was she to her self-defined patriotic mission that she remained immune to the artistic innovations swirling through New York in the 1950s and 1960s, like abstract expressionism and Pop Art. In the absence of further artistic development, her work remained documentary and conventional.

schafts- und Porträtphotographien mit Antiken- und Architekturaufnahmen. Ihre Arbeiten waren formal experimentell, inhaltlich konventionell. Gleichzeitig können sie als persönliches Statement auf die Frage gelten, ob die zeitgenössischen von den antiken Griechen abstammten oder ob sich durch die lange türkische Besatzung die verschiedenen Völker vermischt hätten, wie der deutsche Historiker Jacob Philipp Fallmerayer behauptet und unter den Zeitgenossen einen Sturm der Empörung entfacht hatte.[41]

Mit einer ihrer patriotisch inspirierten Photomontagen versuchte Nelly einen physiognomischen Typus herauszuarbeiten, der sich über die Jahrtausende in Griechenland erhalten hatte. Die anderen Collagen zeigten schlicht die landschaftliche und architektonische Schönheit des Landes. Doch Griechenland spielte im damals kriselnden Europa keine prominente politische oder zeitgenössisch kulturelle Rolle. Im modernen, technikorientierten Kontext der Weltausstellung in New York wirkten Nellys Montagen wie ein romantischer Blick in eine ›ideale‹ Vergangenheit.

Der Ausbruch des Krieges überraschte Nelly und ihren Mann, so daß sie beschlossen, erst einmal in New York zu bleiben. Die Nachricht vom Krieg in Europa rief die schmerzlichen Erinnerungen an die Vertreibung der kleinasiatischen Griechen wieder wach.

Der erzwungene Neuanfang in Amerika war schwer. Doch mit Unterstützung der dortigen griechischen Gemeinde arrangierte sich das Ehepaar Seraidaris in der neuen Heimat. Bald stellten sich auch erste Erfolge ein: Sie zeigte ihre Griechenlandaufnahmen in der griechischen Botschaft in Washington und in Galerien in New York. Einige Monate später erschien ihr Photo eines griechischen Soldaten in traditioneller Tracht mit dem Olympieion im Hintergrund als Titelbild von *Life*.[42] 1947 wurden dort weitere Photographien von Nelly veröffentlicht, mit denen sie wiederum die Ähnlichkeit antiker und zeitgenössischer griechischer Kultur zu verdeutlichen und auch hier eine Typologie der Griechen zu entwickeln beabsichtigte. Mit ihren Veröffentlichungen, Vorträgen und der Organisation von Wohltätigkeitsveranstaltungen versuchte sie, ihrem Heimatland zu helfen, das 1940 von Italien angegriffen und kurze Zeit später von der deutschen Wehrmacht besetzt wurde. So avancierte sie zu einer »inoffiziellen griechischen Botschafterin in den USA«. Ihr amerikanischer Kollege baltischer Herkunft, George Hoyningen-Huene, der Griechenland in den dreißiger Jahren mehrfach bereist hatte, arbeitete ebenfalls für die »Hellenic Aid Campaign«. Sein Bildband *Hellas*, der 1943 in New York erschien, diente der Unterstützung dieser institutionalisierten Griechenlandhilfe.[43] In Griechenland selbst arbeitete Nellys Kollegin Voula Papaioannou Anfang der vierziger Jahre mit ihren Mitteln gegen die deutsche Besatzung: Sie photographierte die erschöpft heimkehrenden und verwundeten Soldaten, später die Flüchtlinge und die hungernden Kinder in den

After the end of the war, Nelly undertook several journeys to Europe, but she and her husband did not return to Athens permanently until 1966. They moved to Nea Smirni, a district occupied mainly by the Greek refugees from Smyrna and Asia Minor, like Nelly's own family. In 1985, she donated her entire photo archive to the Benaki Museum in Athens.

An examination of Nelly's work gives rise to inevitable problems in dating, since she rarely labeled or dated her photos. Today, after her death, only the subject of a photo is left to indicate an approximate date—or at least the topographic attribution to Dresden or to Athens, to the early or the late 1920s.

Nelly's work remains exemplary of the historic development of photography from the 1920s to the 1960s, of the tension between tradition and experiment, of the movement from conventional portraiture to modern dance photography and urban snapshot journalism. Her situational dance photos on the Acropolis fused contemporary culture and classical architecture into individual stylistic expression. The combination of modern expressive dance and antique ideal exemplified Nelly's own artistic achievement. Nelly did not experiment as radically with the diverse expressive possibilities of the medium as her avant-garde contemporaries like László Moholy-Nagy, André Kertesz, Man Ray, or Alexander Rodchenko. But in Greece, a country in which photography had been pursued in an entirely conventional fashion until her arrival, her modern view of Greek history set new artistic standards.

Voula Papaioannou, Soup kitchen / Öffentliche Speisung, Athens, 1940/41

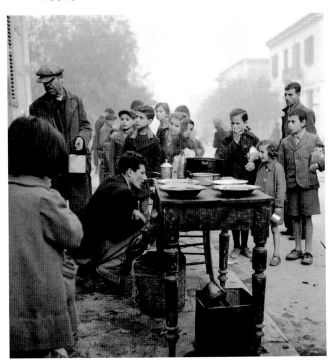

Straßen Athens.[44] Im Gegensatz zu Papaioannous unmittelbaren Beobachtungen während des Zweiten Weltkrieges und des folgenden Bürgerkrieges, die den Ideen einer ›straight photography‹ entsprachen, wirkten Nellys arrangierte Gruppenporträts der griechisch-kleinasiatischen Flüchtlinge Ende der zwanziger Jahre wie sakrale Motive in Gemälden von Raffael oder Pontormo.

In New York begleitete Nelly kleinere und größere Ereignisse in der dortigen griechischen Gemeinde photographisch. Sie porträtierte bekannte Griechen, die in der Metropole lebten oder diese besuchten. An die früheren Bildleistungen konnte sie jedoch nicht mehr anknüpfen. Sie stand so sehr im patriotischen Dienst der selbst gestellten Aufgabe, daß sie von den künstlerischen Innovationen im New York der fünfziger und sechziger Jahre, des Abstrakten Expressionismus oder der Pop Art unbeeinflußt blieb. Ihre Arbeit war weiterhin eher dokumentarisch und konventionell, als daß sie sich künstlerisch weiterentwickelte.

Nach Kriegsende besuchte Nelly mehrfach Europa, doch erst 1966 kehrte sie gemeinsam mit ihrem Ehemann endgültig nach Athen zurück und ließ sich in Nea Smirni nieder. Dieser Stadtteil wurde in erster Linie von Flüchtlingen griechischer Abstammung bewohnt, die Anfang der zwanziger Jahre aus Smyrna und der Umgebung vertrieben worden waren, wie damals auch Nellys eigene Familie. 1985 vermachte sie ihr gesamtes photographisches Archiv dem Benaki-Museum in Athen.

In der Auseinandersetzung mit Nellys Werk stößt man unweigerlich auf Datierungsschwierigkeiten, da sie die wenigsten Bilder datiert oder bezeichnet hat. Auch die postume, topographische Zuordnung ihrer Porträts nach Dresden oder Athen, d.h. die Datierung in die frühen oder späten zwanziger Jahre ist postum häufig nur über den Bildgegenstand annäherungsweise zu bestimmen.

Nellys Werk bleibt exemplarisch für die Entwicklung der Photographiegeschichte von den zwanziger Jahren bis in die sechziger Jahre: Zwischen Tradition und Experiment, von den konventionellen Porträts über die moderne Tanzphotographie zum Bildjournalismus urbaner Prägung. In ihren situativen Tanzbildern auf der Akropolis verband Nelly zeitgenössische Kultur und klassische Architektur zu einem individuellen Stilmittel. Diese Verknüpfung von modernem Ausdruckstanz und antikem Ideal zeigt die eigene künstlerische Leistung Nellys. Im Gegensatz zu ihren avantgardistischen Zeitgenossen László Moholy-Nagy, André Kertesz, Man Ray oder Alexander Rodtschenko experimentierte Nelly zwar weniger mit den vielfältigen Ausdrucksmöglichkeiten des Mediums. Doch in Griechenland, einem Land, in dem Photographie bis dahin eher konventionell betrieben wurde, konnte sie mit ihrem zeitgenössischen Blick auf die griechische Geschichte neue künstlerische Standards setzen.

1 Following the photographers who worked in Athens in the 1860s and 1870s—Dimitrios Konstantinou, Pascal Sébah, Paul Baron des Granges, and William James Stillman—the subsequent generation of Alois Beer, Bartolommeo Borri, Konstantin Athanasiou, the Moraitis brothers, and Carl Boehringer especially catered to the tourist demand for memorable images with their pictures of temples dating from the 1880s to the turn of the century—a period in which Athens grew from a sleepy town into a city of about 100,000 residents. Cf. Dorothea Ritter, "Griechenland—Vorstellungen und Photographien im 19. Jahrhundert," in: *Im Lichte des Helios. Griechenland in frühen Photographien aus der Sammlung Siegert*, exh. cat., Schack-Galerie (Munich, 1999), p. 25.

2 Cf. *Nellys Autobiography*, ed. Emanuel Casdaglis (Athens: Anagramma, 1989), p. 51.

3 Adelheid Rasche, *XTC. Ecstasy—Tanzfotografie der zwanziger Jahre aus der Kunstbibliothek*, Lipperheidische Kostümbibliothek, exh. cat., Kunstbibliothek, Staatliche Museen zu Berlin, Preussischer Kulturbesitz (Berlin, 1996), p. 3

4 Rasche, ibid., p. 5

5 Dance art of this period was not limited to expressive dance. For example, a number of "formally abstracting dance experiments" (in space dance, baton dance, gestural dance) using rhythmical music on an empty stage were undertaken starting in 1926 at the Dessau Bauhaus under the direction of Oskar Schlemmer. Cf. Rasche, ibid., p. 4.

6 Franz Fiedler, "Photographische Wanderfahrt in Hellas," in: Deutscher Kamera Almanach, 19, 1929, pp. 99-118, quote p. 104. To Fiedler, "the journey to Greece is by far the most spiritual of all journeys," ibid.

7 See Fiedler's portrait of two Cretans in ibid., p. 112, and Nelly's almost identical shot in "Athens 1924–1939."

8 Cf. *Akropolis*, a volume "as recorded by Walter Hege and described by Gerhart Rodenwaldt," (Berlin: Deutscher Kunstverlag, 1930, further eds. in 1935, 1937, 1941 and 1956), and Hege/Rodenwaldt's subsequent tomes, *Olympia* (Berlin: Deutscher Kunstverlag, 1935, 2nd ed. 1937) and *Griechische Tempel* (Berlin: Deutscher Kunstverlag, 1941, 2nd ed. 1956).

9 Cf. Helmut Grunwald. *Franz Fiedler und seine Zeit* (Halle: fotokinoverlag, 1960), p. 61.

10 *Ideale Körper-Schönheit*, vol. 2 (Dresden: Vitus-Verlag, 1924). Appearing on pages 17, 19, 21, 23, 33 und 39, Nelly's first published photos are attributed to "Elly Nellys" and bear the titles, in order: Youth Nude, Outdoor Study, Demon, Sundance, Rhythm, and Studio Hour. The Dresden-based publisher Vitus-Verlag published many volumes of dance and nude photography in the 1920s. A few of Nelly's photos and Bromoil prints from her time in Dresden are signed with "Elly."

11 Cf. ibid., p. 5. Whether Nelly was able to sell any of her photos or oil prints in this way is unclear.

12 Cf. a nude from the rear by Franz Fiedler, taken in his Dresden studio, in Die Schönheit 20, no. 9, 1924, p. 411. For a photographer showcased in another issue of this journal, see: "Jan Pepino. Ein deutscher Lichtbild-Dichter. Zu Lichtbildern Josef Bayers," in: Die Schönheit 21, no. 4, 1925, pp. 201ff.

13 Ulf Erdmann Ziegler. *Nackt unter Nackten. Utopien der Nacktkultur 1906–1942*, photographs from Sammlung Scheid (Herrsching: Pawlak, 1992), p. 25.

14 Helmut Grunwald. *Franz Fiedler und seine Zeit*, p. 86.

15 Angelika Beckmann, "'Grosser Stil ist Einfachheit.' Hugo Erfurth und seine Schüler Franz Fiedler, Walter Hege und Elli Seraidari (Nelly's)," in: *Hugo Erfurth 1874–1948. Photograph zwischen Tradition und Moderne*, eds. Bodo von Dewitz and Karin Schuller-Procopovici, exh. cat., Agfa Foto-Historama (Cologne, 1992), pp. 74ff, quote p. 82.

16 Cf. Nelly's facsimiled diploma in: *Nellys Autobiography*, p. 67. The inscription is in French, followed by a German text stating: "Diploma—It is hereby confirmed that Fräulein Elly Sujulzoglu, born on November 10, 1899 in Aydin, Turkey, has completed a course of training in artistic photography and is thus capable of independent practice in this profession."

17 Cf. Alkis X. Xanthakis. *History of Greek Photography 1839–1960*, (Athens: Hellenic Literary and Historical Archives Society, 1988), pp. 157f.

18 Cf. *Nellys Autobiography*, pp. 69ff.

19 Cf. *Tanz:Foto. Annäherungen und Experimente 1880–1940*, ed. Monika Faber, exh. cat., Austrian Photo Archive at the Museum moderner Kunst, (Vienna, 1991); and Beckers/Moortgat, "Tanz - Photographie - Bewegung," in: Beckers/Moortgat, Atelier Lotte Jacobi. Berlin - New-York (Berlin: Nicolai, 1997), pp. 102ff.

20 Cf. Pavlos Nirvanas' column in Elefteron Vima, 20 November 1929, and *Nellys Autobiography*, pp. 103f. Also cf. Irene Boudouri, "Dance Photography and the Classical Ideal," in: *Nelly's. Body and Dance*, ed. Benaki-Museum (Athens, 1997), p. 26.

21 See the photo of Nikolska leaping under the title, "La Folie de l'Acropole," in Voilà. L'Hebdomadaire du Reportage, IV/168, p. 9, June 1934. Cf. *Nelly's. Body and Dance.*

22 Cf. *Tanz:Foto*, pp. 11ff.

23 Frank-Manuel Peter, "'Das tänzerische Lichtbild.' Hugo Erfurth als Dokumentarist des frühen Ausdruckstanzes," in: *Hugo Erfurth 1874–1948*, pp. 45ff, quote p. 47. Like Nelly, dance photographer Charlotte Rudolph trained under Erfurth.

1 Nach den Photographen, die in den sechziger und siebziger Jahren des 19. Jahrhunderts in Athen arbeiteten – Dimitrios Konstantinou, Pascal Sébah, Paul Baron des Granges oder William James Stillman –, waren es insbesondere Alois Beer, Bartolommeo Borri, Konstantin Athanasiou, die Gebrüder Moraitis oder Carl Boehringer, die mit ihren Tempelbildern aus den achtziger Jahren bis zur Jahrhundertwende, als Athen eine Metropole mit etwa einhunderttausend Einwohnern geworden war, dem Bedürfnis der Touristen nach bildhaften Erinnerungen nachkamen. Vgl. Dorothea Ritter, ›Griechenland – Vorstellungen und Photographien im 19. Jahrhundert‹, in *Im Lichte des Helios. Griechenland in frühen Photographien aus der Sammlung Siegert*, Ausstellungskatalog Schack-Galerie, München, 1999, S. 25

2 Vgl. *Nellys Autobiography*, hrsg. v. Emanuel Casdaglis, Athen: Anagramma, 1989, S. 51.

3 Adelheid Rasche, in *XTC. Ecstasy – Tanzfotografie der zwanziger Jahre aus der Kunstbibliothek*, Ausstellungskatalog Kunstbibliothek, Staatliche Museen zu Berlin Preußischer Kulturbesitz, 1996, S. 3

4 Rasche, ebenda, S. 5

5 Künstlerischer Tanz beschränkte sich in dieser Zeit nicht auf den Ausdruckstanz. So entstanden ab 1926 am Dessauer Bauhaus unter der Leitung von Oskar Schlemmer »formal abstrahierende Tanzexperimente« (Raumtanz, Stäbeltanz, Gestentanz) zu rhythmisierender Musik auf leerer Bühne. Vgl. Rasche, ebenda, S. 4

6 Franz Fiedler, ›Photographische Wanderfahrt in Hellas‹, in *Deutscher Kamera Almanach 19*, 1929, S. 99-118, hier: S. 104. Für Fiedler ist die »Reise nach Griechenland entschieden von allen Reisen die geistigste«, ebenda.

7 Vgl. dazu Fiedlers Porträt zweier Kreter, in: Franz Fiedler, a.a.O., S. 112, sowie Nellys beinahe identisches Porträt im Kapitel ›Athen 1924-1939‹.

8 Vgl. *Akropolis, aufgenommen von Walter Hege, beschrieben von Gerhart Rodenwaldt*, Berlin: Deutscher Kunstverlag, 1930 (weitere Auflagen: 1935, 1937, 1941, 1956); *Olympia, aufgenommen von Walter Hege, beschrieben von Gerhart Rodenwaldt*, Berlin: Deutscher Kunstverlag, 1935 (2. Auflage 1937); *Griechische Tempel, aufgenommen von Walter Hege, beschrieben von Gerhart Rodenwaldt*, Berlin: Deutscher Kunstverlag, 1941 (2. Auflage 1956).

9 Vgl. Helmut Grunwald, *Franz Fiedler und seine Zeit*, Halle: fotokinoverlag, 1960, S. 61.

10 *Ideale Körper-Schönheit*, 2. Band, Dresden: Vitus-Verlag, 1924. Nellys Bilder finden sich – unter der Autorenangabe ›Elly Nellys‹ – in ihrer ersten Publikation auf den Seiten 17, 19, 21, 23, 33 und 39. Die Titel – in gleicher Reihenfolge – sind: *Jünglingsakt, Freilichtstudie, Dämon, Sonnentanz, Rhythmus* und *Atelierstudie*. Der Vitus-Verlag gab in den zwanziger Jahren zahlreiche Publikationen zur Tanz- und Aktphotographie heraus. Einige von Nellys Photographien und Bromöldrucken aus der Dresdner Zeit sind rückseitig mit Bleistift ›Elly‹ signiert.

11 Vgl. ebenda, S. 5. Ob Nelly auf diese Weise einige ihrer Photographien und Öldrucke hatte verkaufen können, bleibt unklar.

12 Vgl. den Rückenakt von Franz Fiedler, aufgenommen vermutlich in dessen Dresdner Studio, in: *Die Schönheit 9, xx. Jahrgang*, 1924, S. 411. In einigen Ausgaben der Zeitschrift wurden auch Photographen vorgestellt, beispielsweise: Jan Pepino, ›Ein deutscher Lichtbild-Dichter. Zu Lichtbildern Josef Bayers‹, in: *Die Schönheit 4, xxi. Jahrgang*, 1925, S. 201ff.

13 Ulf Erdmann Ziegler, *Nackt unter Nackten. Utopien der Nacktkultur 1906–1942, Photographien aus der Sammlung Scheid*, Herrsching: Pawlak, 1992, S. 25.

14 Helmut Grunwald, *Franz Fiedler und seine Zeit*, a.a.O., S. 86.

15 Angelika Beckmann, ›"Großer Stil ist Einfachheit". Hugo Erfurth und seine Schüler Franz Fiedler, Walter Hege und Elli Seraidari (Nelly's)‹, in *Hugo Erfurth 1874–1948. Photograph zwischen Tradition und Moderne*, hrsg. v. Bodo von Dewitz und Karin Schuller-Procopovici, Ausstellungskatalog Agfa Foto-Historama, Köln 1992, S. 74ff, hier: S. 82.

16 Vgl. Nellys faksimilierte Diplomurkunde, in: *Nellys Autobiography*, a.a.O., S. 67. Im deutschen Wortlaut, dem ein französischer folgt, heißt es: »Diplom – Frl. Elly Sujulzoglu geboren am 10. November 1899 zu Aidin in der Türkei wird hierdurch bescheinigt, daß sie in der künstlerischen Photographie eine abschließende Ausbildung erlangt hat, die sie zur selbständigen Ausübung dieses Berufes befähigt.«

17 Vgl. Alkis X. Xanthakis, *History of Greek Photography 1839–1960*, Athen: Hellenic Literary and Historical Archives Society, 1988, S. 157f.

18 Vgl. *Nellys Autobiography*, a.a.O., S. 69ff.

19 Vgl. dazu *Tanz: Foto. Annäherungen und Experimente 1880–1940*, hrsg. v. Monika Faber, Ausstellungskatalog Österreichisches Fotoarchiv im Museum moderner Kunst, Wien, 1991, sowie Beckers/Moortgat, ›Tanz – Photographie – Bewegung‹, in: Beckers/Moortgat, *Atelier Lotte Jacobi. Berlin – New-York*, Berlin: Nicolai, 1997, S. 102ff.

20 Vgl. Pavlos Nirvanas, in *Elefteron Vima*, 20. November 1929, sowie *Nellys Autobiography*, a.a.O., S. 103f. Vgl. auch Irene Boudouri, ›Dance Photography and the Classical Ideal‹, in *Nelly's. Body and Dance*, hrsg. v. Benaki-Museum, Athen, 1997, S. 26.

21 Vgl. das Titelbild mit dem Motiv der springenden Nikolska und dem Titel ›La Folie de l'Acropole‹, in *Voilà. L'Hebdomadaire du Reportage, iv/168*, 9. Juni 1934. Vgl. auch die umfangreiche Publikation zu Nellys Tanzphotographie: *Nelly's Body and Dance*, a.a.O.

In a 1930 article she formulated solutions for the problem of translating dynamic dance into static stills. Cf. Rasche, XTC. Ecstasy—Tanzfotografie, p. 4.

24 Peter, p. 48.

25 Cf. Matthias Harder. Wanderer, kommst Du nach Hellas… Deutsche Photographen sehen Griechenland in der ersten Hälfte des 20. Jahrhunderts, exh. cat., Goethe-Institut of Thessaloniki (1997), pp. 21ff., 48.

26 Nelly, quoted in Eurydice Trichon-Milsani, "Nelly, a Greek Photographer," in: Dionissis Fotopoulos, Nelly's, ed. Agricultural Bank of Greece (Athens, 1990), p. 46.

27 Cf. Nellys Autobiography, p. 80.

28 On Boissonnas and his publications, see Bodo von Dewitz, "Das Land der Griechen mit der Seele suchen," in: Das Land der Griechen mit der Seele suchen. Photographien des 19. und 20. Jahrhunderts, exh. cat., ed. Agfa Photo-Historama (Cologne, 1990), p. 229.

29 Cf. Xanthakis, p. 161 (as in note 17).

30 Dewitz, pp. 19f.

31 Cf. Angelos Seraidaris. Photographic Itinerary on Mount Athos 1935, exh. cat., Benaki-Museum (Athens, 1995); Matthias Harder, "Klöster und Mönche auf dem Berg Athos. Photographien von Angelos Seraidaris," in: Chronika, Monatsmagazin für griechische Kultur 4, June 1997, pp. 13ff.

32 Cf. Gert Koshofer, "Walter Hege und die Farbphotographie," in: Dom Tempel Skulptur. Architekturphotographien von Walter Hege, ed. Angelika Beckmann and Bodo von Dewitz, exh. catalogue, Agfa Foto-Historama (Cologne, 1993), pp. 73ff.; also, Farbe im Photo. Die Geschichte der Farbphotographie von 1861 bis 1981, exh. cat., Josef Haubrich Kunsthalle (Cologne, 1981).

33 Xanthakis, p. 180f. writes that Nelly had experimented earlier with Autochrome plates, a stage on the way to full color photography. Erfurth also "made a large number of Autochrome prints" in 1908, according to Das Atelier des Photographen 15, 1908, p. 61f., as quoted in Rolf Sachsse, "Die Bildleistungen der Spezialistenzeit," in: Farbe im Photo, p. 121.

34 Cf. Nellys Autobiography, p. 170f.

35 Mariot presented his first Öldruck prints in 1866. Hewitt followed in 1909 with the first Bromoils. Both techniques are gelatin-free and allow a print in several colors. Cf. Verfahren der Fotografie, exh. cat., designed by Robert Knodt and Klaus Pollmeier for the Photography Collection of Museum Folkwang (Essen, 1989), p. 74.

36 Beckmann (as in note 15), p. 83.

37 Bodo von Dewitz used this as the cover picture for the exhibition catalogue, Das Land der Griechen mit der Seele suchen (as in note 28).

38 In the making of their Olympia ten years later, Leni Riefenstahl and her cameraman Willi Zielke presumably drew on Nelly's temple photos and her extraordinary portraits of athletes on the Acropolis. Cf. Leni Riefenstahl. Olympia (London: Quartet Books, 1994).

39 Edward Steichen, Ein Leben für die Fotografie (Vienna/Dusseldorf: Econ, 1965), quote from ch. 6, "Nach Griechenland mit den Duncan-Isadorables."

40 Ibid., see plates on pp. 84ff.

41 Cf. Jacob Philipp Fallmerayer. Geschichte der Halbinsel Morea während des Mittelalters (Leipzig, 1836). Early Philohellenism was thus followed by disillusionment among travelers to Greece.

42 Life, 16 December 1940; cf. Fotopoulos (as in note 26), p. 437, pl. 479.

43 George Hoyningen-Huene, Hellas (New York: J.J. Augustin, 1943). Hoyningen-Huene und Herbert List also traveled through Greece together, both taking very similar photos, sometimes from the same vantage points. The publication of List's photo volume, Licht über Hellas, originally planned in 1939, was delayed until 1953 by the war and its aftermath.

44 Cf. Voula Papaioannou. Bilder der Verzweiflung und Hoffnung. Griechenland 1940–1960, exh. cat., ed. Stiftung für Griechische Kultur/Benaki-Museum (Berlin, 1995); also, Matthias Harder, "Voula Papaioannou. Bilder der Verzweiflung und Hoffnung. Griechenland 1940–1960," Photonews, Dec. 1996/Jan. 1997, pp. 4f.

22 Vgl. Tanz: Foto, a.a.O., S. 11ff.

23 Vgl. Frank-Manuel Peter, ›Das tänzerische Lichtbild‹. Hugo Erfurth als Dokumentarist des frühen Ausdruckstanzes‹, in Hugo Erfurth 1874–1948, a.a.O., S. 45ff., hier: S. 47. Die Tanzphotographin Charlotte Rudolph war wie Nelly Schülerin von Erfurth und formulierte 1930 in einem Artikel Lösungen für das Problem der Umsetzung des dynamischen Tanzes in ein statisches Bild. Vgl. Rasche, in XTC. Ecstasy – Tanzfotografie, a.a.O., S. 4.

24 Frank-Manuel Peter, ›Das tänzerische Lichtbild‹ …‹, a.a.O., S. 48.

25 Vgl. dazu: Matthias Harder, Wanderer, kommst Du nach Hellas… Deutsche Photographen sehen Griechenland in der ersten Hälfte des 20. Jahrhunderts, Ausstellungskatalog Goethe-Institut Thessaloniki, 1997, S. 21ff., 48.

26 Nelly, zit. nach Eurydice Trichon-Milsani, ›Nelly, a Greek Photographer‹ in Dionissis Fotopoulos, Nelly's, hrsg. v. Agricultural Bank of Greece, Athen, 1990, S. 46.

27 Vgl. Nelly's Autobiography, a.a.O., S. 80.

28 Zu Boissonnas und seinen Buchveröffentlichungen vgl. Bodo von Dewitz, ›Das Land der Griechen mit der Seele suchen‹, in Das Land der Griechen mit der Seele suchen. Photographien des 19. und 20. Jahrhunderts, Ausstellungskatalog, hrsg. v. Agfa Foto-Historama, Köln, 1990, S. 229.

29 Vgl. Xanthakis, History of Greek Photography 1839–1960, a.a.O., S. 161.

30 Bodo von Dewitz, ›Das Land der Griechen mit der Seele suchen‹, in Das Land der Griechen mit der Seele suchen. …‹, a.a.O., S. 19f.

31 Vgl. Angelos Seraidaris, Photographic Itinerary on Mount Athos 1935, Ausstellungskatalog Benaki-Museum, Athen, 1995, sowie Matthias Harder, ›Klöster und Mönche auf dem Berg Athos. Photographien von Angelos Seraidaris‹, in Chronika, Monatsmagazin für griechische Kultur, IV, Juni 1997, S. 13ff.

32 Vgl. dazu Gert Koshofer, ›Walter Hege und die Farbphotographie‹, in Dom, Tempel, Skulptur. Architekturphotographien von Walter Hege, hrsg. v. Angelika Beckmann und Bodo von Dewitz, Kataloghandbuch Agfa Foto-Historama, Köln, 1993, S. 73ff., sowie Farbe im Photo. Die Geschichte der Farbphotographie von 1861 bis 1981, Ausstellungskatalog, Josef-Haubrich-Kunsthalle Köln, 1981.

33 Vgl. Xanthakis. History of Greek Photography 1839–1960, a.a.O., S. 180. In den Jahren zuvor experimentierte Nelly, so Xanthakis weiter, bereits mit Autochromeplatten, einer Vorstufe der Farbphotographie. Auch ihr Lehrer Hugo Erfurth hatte bereits 1908 eine »größere Anzahl von Aufnahmen auf Autochrome-Material geschaffen«. Vgl. Das Atelier des Photographen, 15, 1908, S. 61f., zit. nach Rolf Sachsse, ›Die Bildleistungen der Spezialistenzeit‹, in Farbe im Photo, a.a.O., S. 121.

34 Vgl. Nellys Autobiography, a.a.O., S. 170f.

35 1866 wurden die ersten Öldrucke von Mariot präsentiert, Hewitt folgte 1909 mit der Vorstellung von Bromöldrucken. Beide Verfahren sind gelatinefrei und können verschiedenfarbig gedruckt werden. Ölumdrucke wurden etwa in der Zeit von 1904 bis in die dreißiger Jahre, Bromöldrucke von 1909 bis in die vierziger Jahre verwendet. Vgl. Verfahren der Fotografie, Ausstellungskatalog, Konzeption von Robert Knodt/Klaus Pollmeier, Fotografische Sammlung im Museum Folkwang, Essen, 1989, S. 74.

36 Beckmann, ›Großer Stil ist Einfachheit‹ …‹, a.a.O., S. 83.

37 Dieses Porträt von Nelly wählte Bodo von Dewitz als Titelbild des von ihm konzipierten Ausstellungskataloges Das Land der Griechen mit der Seele suchen.

38 Leni Riefenstahl und ihr Kameramann Willi Zielke haben sich zehn Jahre später für den Prolog des Olympiafilms vermutlich an Nellys Tempelaufnahmen und an ihren außergewöhnlichen Sportlerporträts auf der Akropolis orientiert. Vgl. Leni Riefenstahl. Olympia, London: Quartet Books, 1994.

39 Edward Steichen, Ein Leben für die Fotografie, Wien/Düsseldorf: Econ, 1965, o.S., hier: Kapitel 6/›Nach Griechenland mit den Duncan-Isadorables‹.

40 Ebenda, vgl. Abb. 84ff.

41 Vgl. Jacob Philipp Fallmerayer, Geschichte der Halbinsel Morea während des Mittelalters, Leipzig, 1836. Dem frühen Philhellenismus folgte damals die Desillusionierung der Griechenlandreisenden.

42 Life, 16. Dezember 1940; vgl. Fotopoulos, Nelly's, a.a.O., S. 437, Abb. 479.

43 George Hoyningen-Huene, Hellas, New York: J.J. Augustin, 1943, Hoyningen-Huene und Herbert List waren zeitweise gemeinsam durch Griechenland gereist und hatten aus teilweise gleichen Blickwinkeln formal sehr ähnlich photographiert. Die Herausgabe von Lists Bildband Licht über Hellas war für 1939 geplant, kam jedoch durch den Kriegsausbruch und die Nachkriegswirren erst 1953 zustande.

44 Vgl. Voula Papaioannou, Bilder der Verzweiflung und Hoffnung. Griechenland 1940–1960, Ausstellungskatalog, hrsg. v. Stiftung für Griechische Kultur/Benaki-Museum, Berlin, 1995. Vgl. auch Matthias Harder, ›Voula Papaioannou. Bilder der Verzweiflung und Hoffnung. Griechenland 1940–1960‹, in Photonews, Dezember 1996/Januar 1997, S. 4f.

DRESDEN

1920–1924

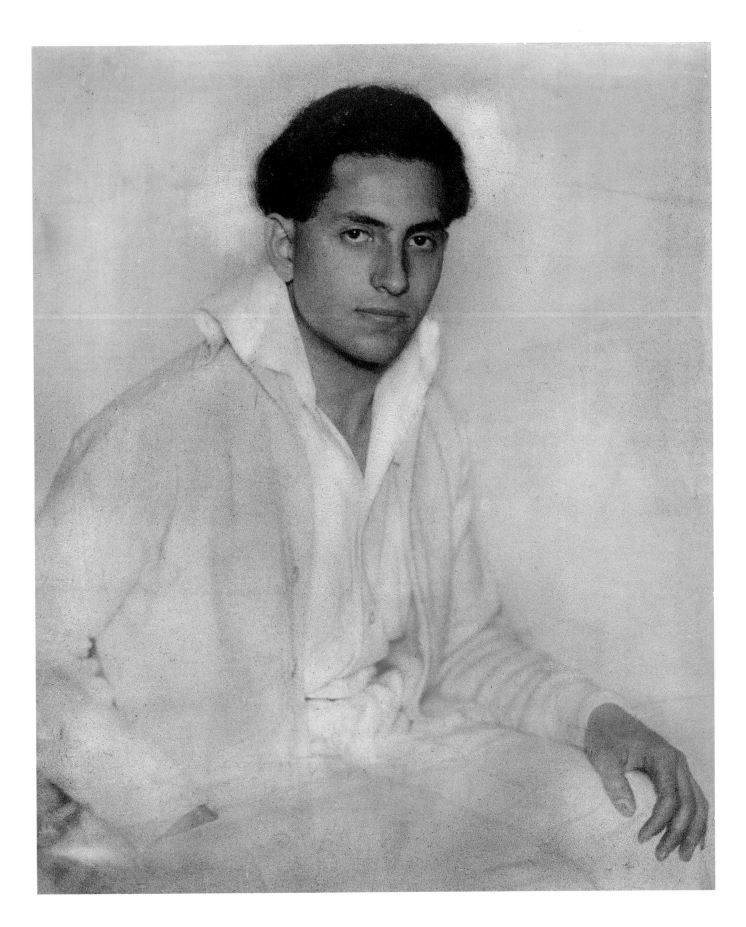

1 Angelos Seraidaris, early 1920s

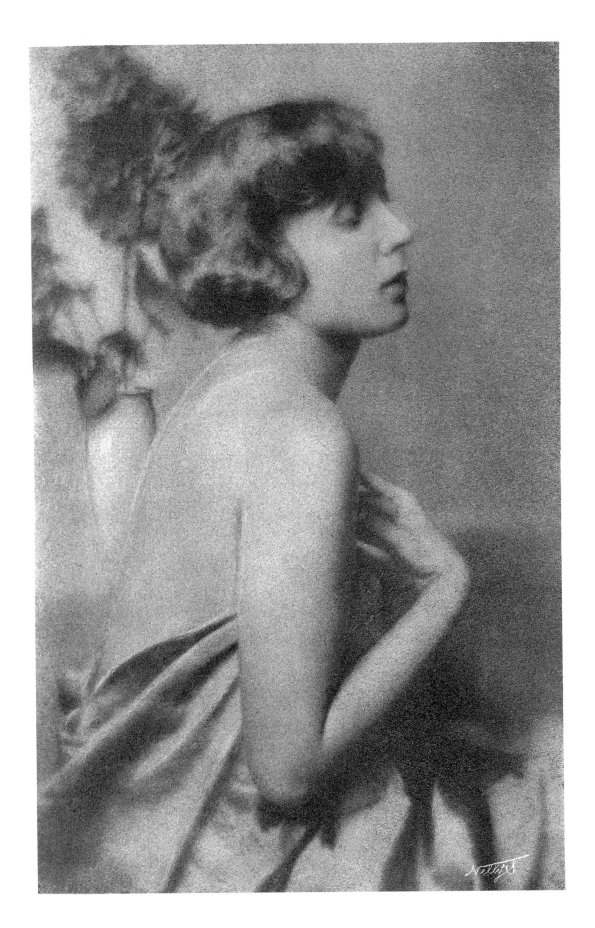

2 Portrait of a woman / Frauenporträt, early 1920s

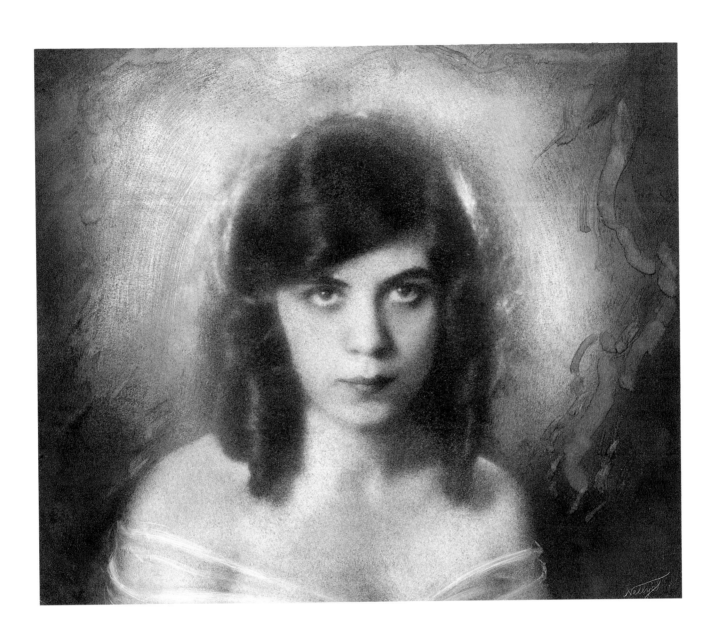

3 Portrait of a young woman / Porträt einer jungen Frau, early 1920s

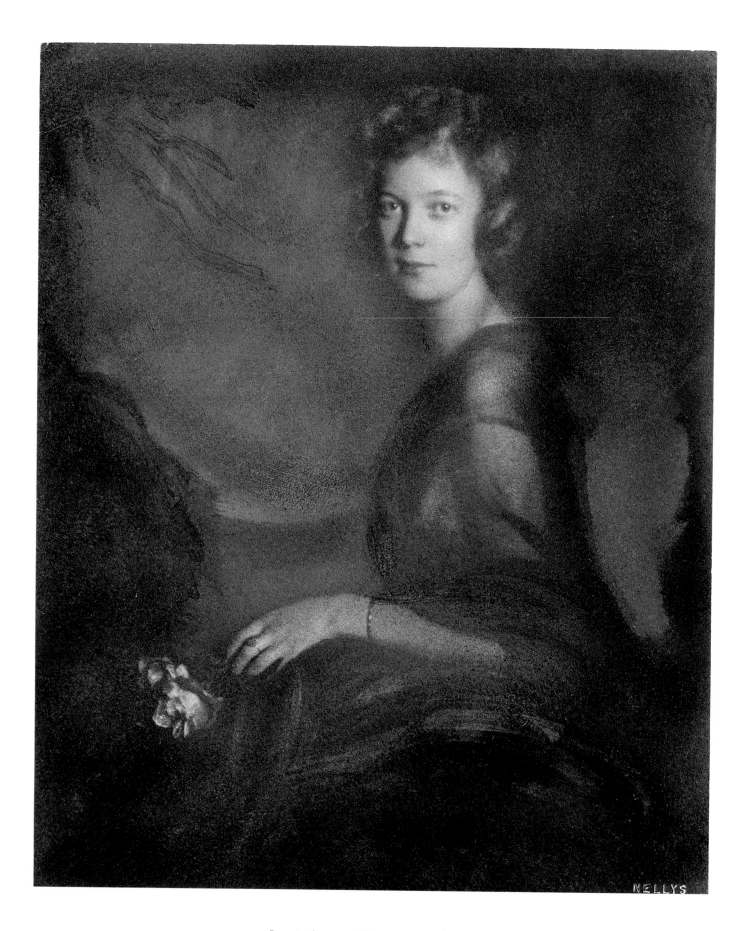

4 Portrait of a woman / Frauenporträt, early 1920s

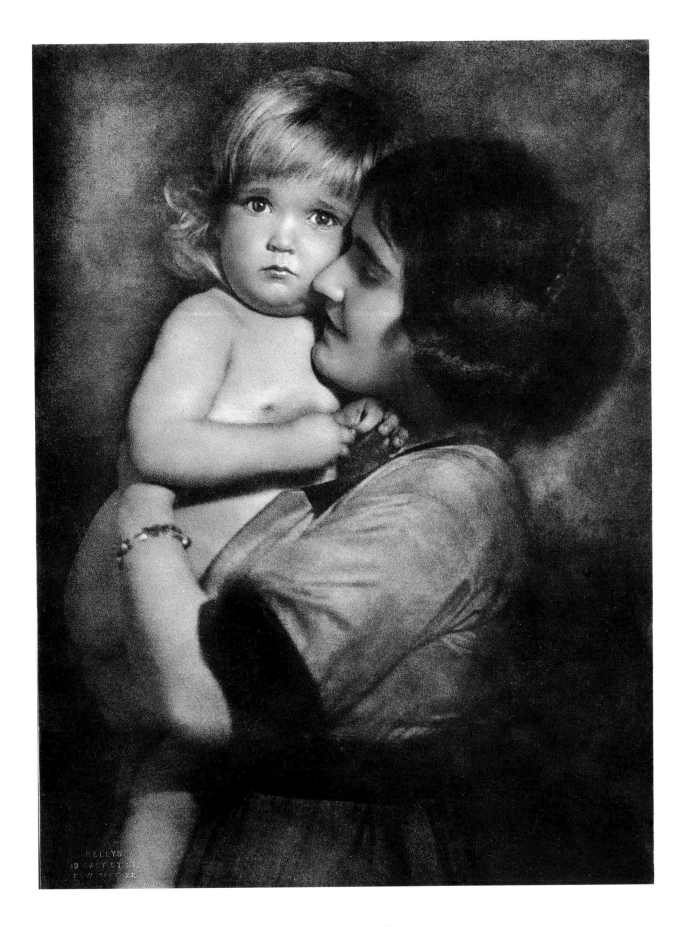

5 Mother and child / Mutter mit Kind, early 1920s

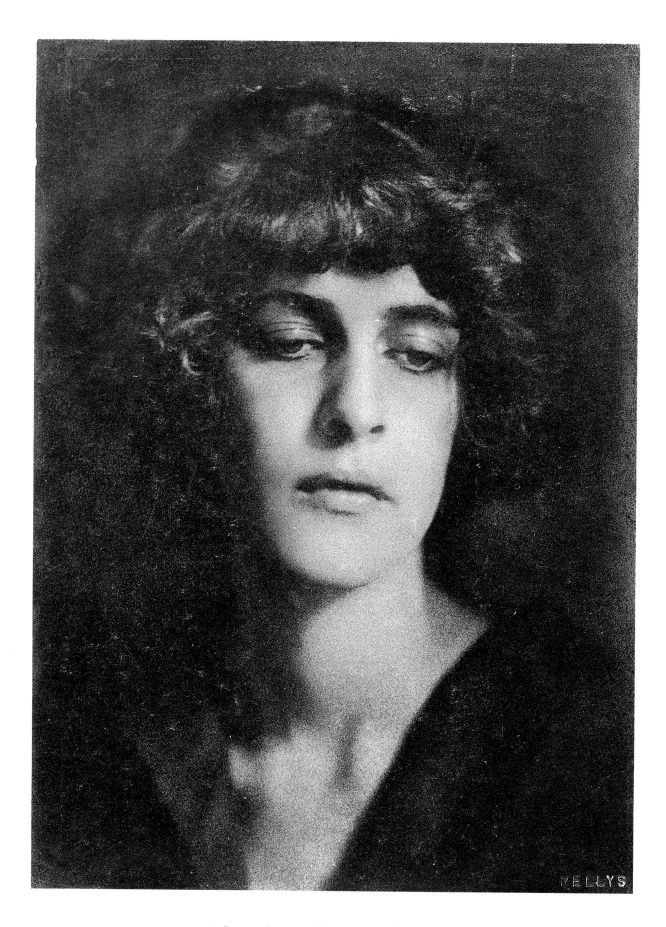

6　Portrait of a woman / Frauenporträt, early 1920s

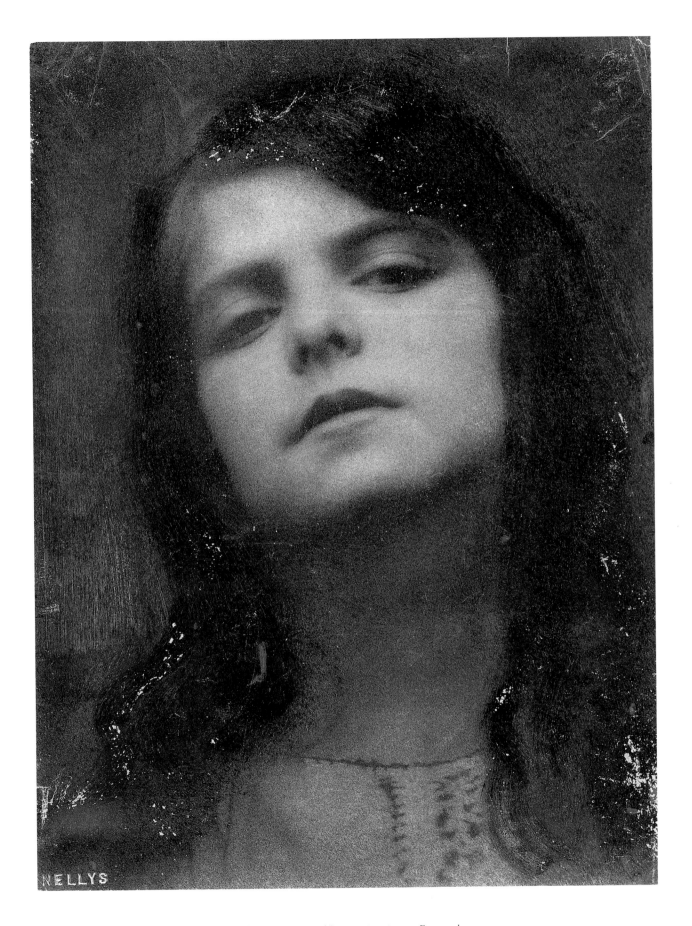

7 Portrait of a young woman / Porträt einer jungen Frau, early 1920s

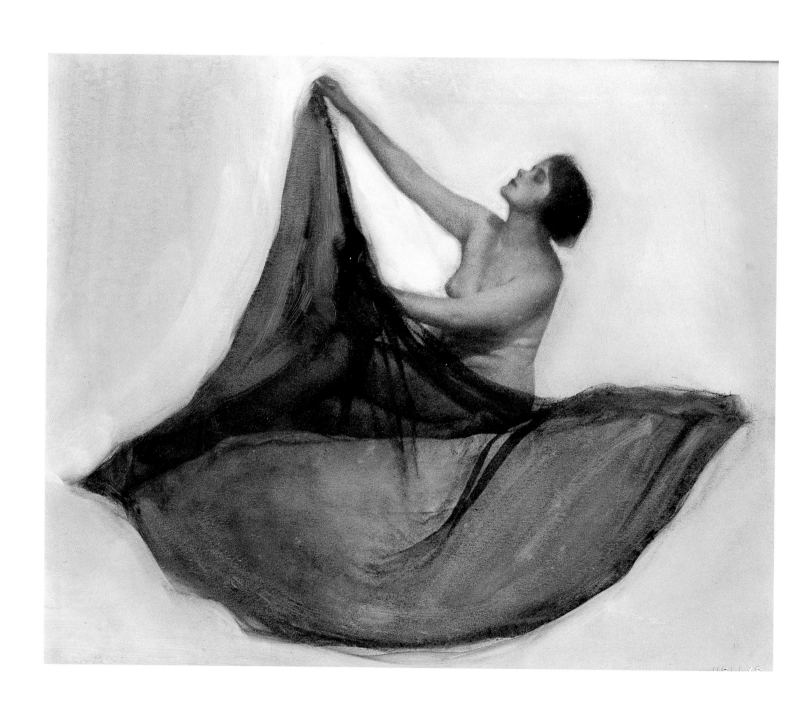

8 Nude / Akt, early 1920s

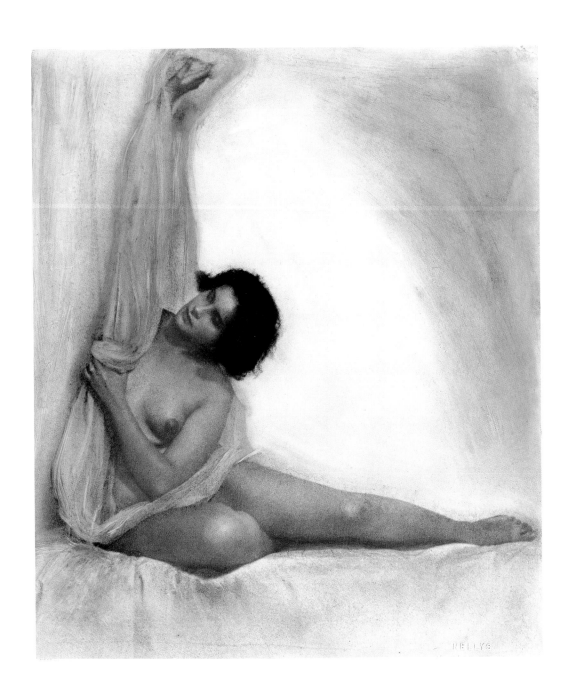

9 Nude / Akt, early 1920s

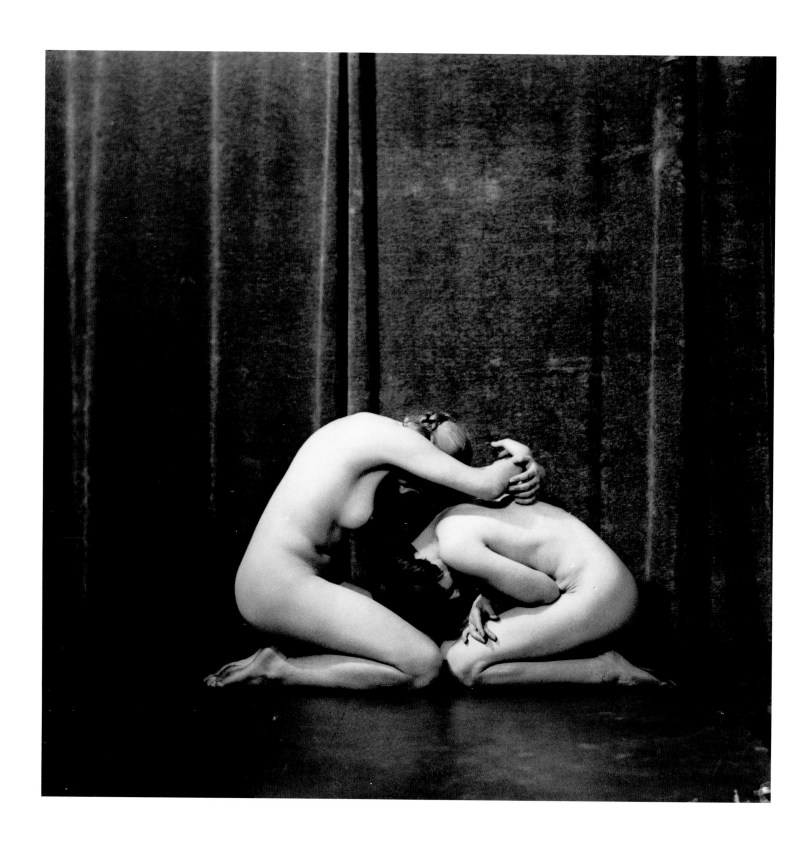

10 Dancers from Mary Wigman's School / Tänzerinnen der Schule von Mary Wigman,
early 1920s

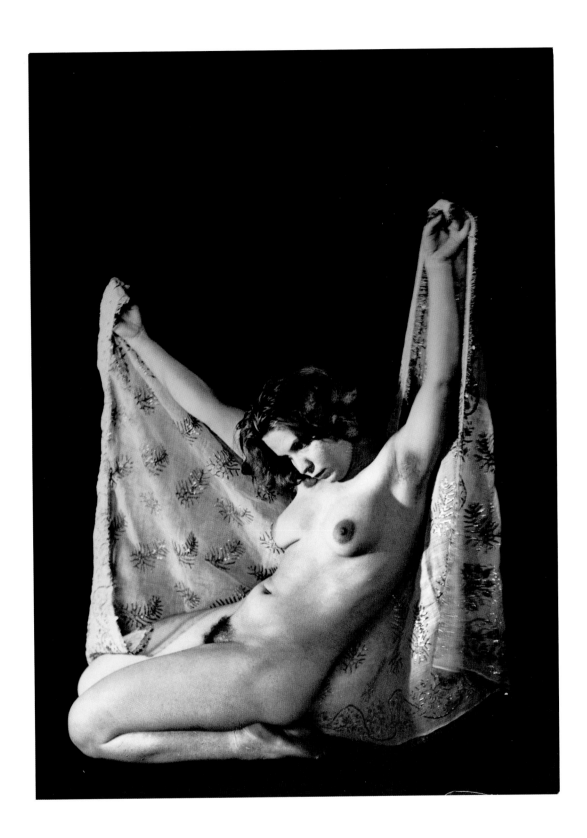

11 Dancer / Ausdruckstänzerin, early 1920s

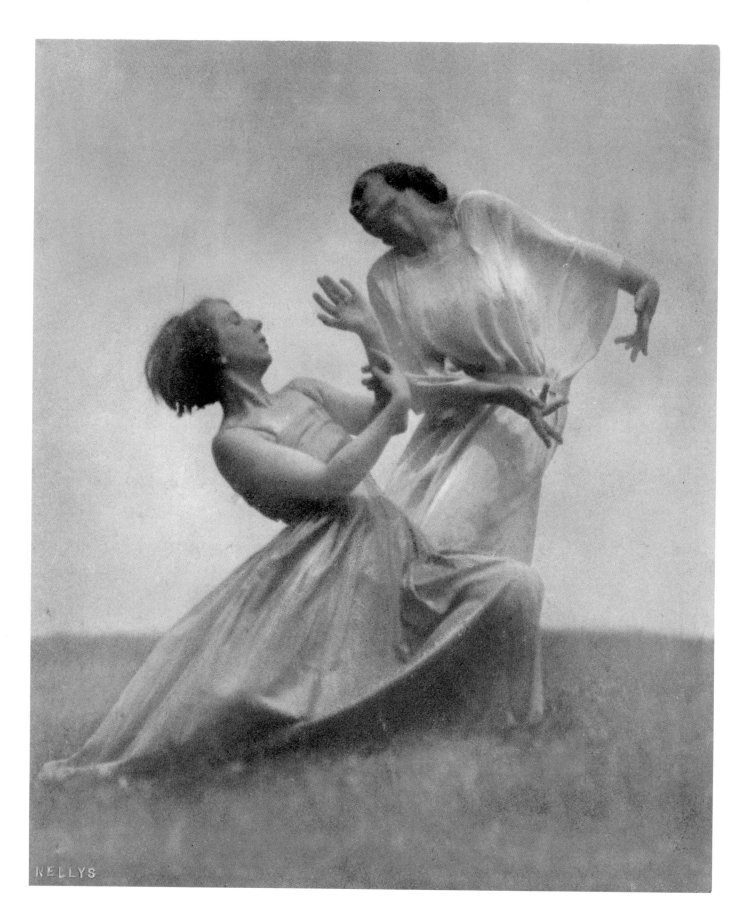

12 Dancers from Mary Wigman's School / Tänzerinnen der Schule von Mary Wigman, 1923

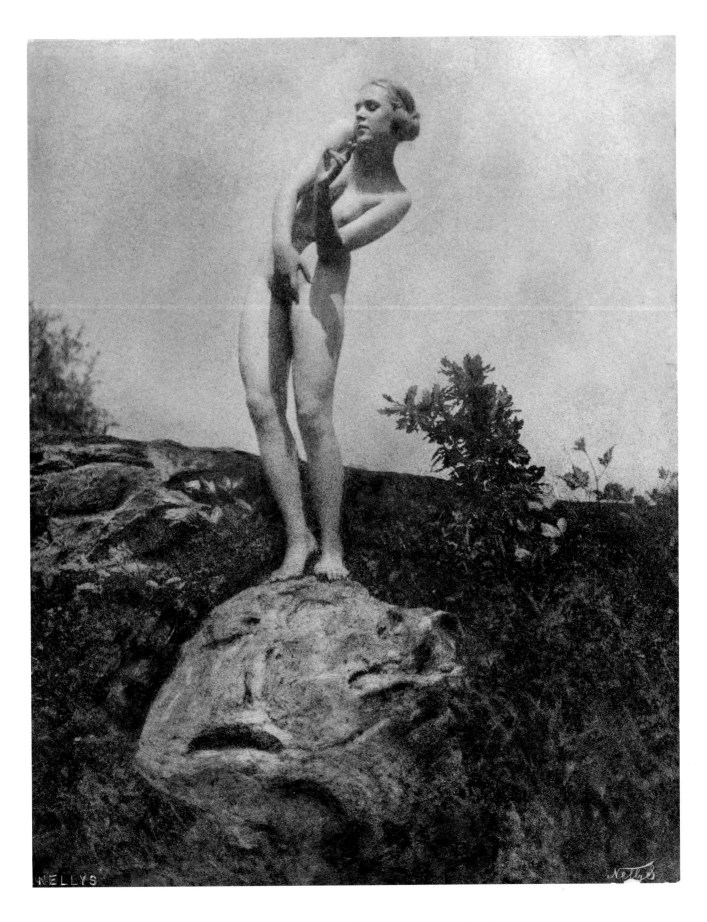

13 Dancer from Mary Wigman's School / Tänzerin der Schule von Mary Wigman, 1923

14 Landscape / Landschaft, 1920s

15 Landscape / Landschaft, early 1920s

ATHENS
1924–1939

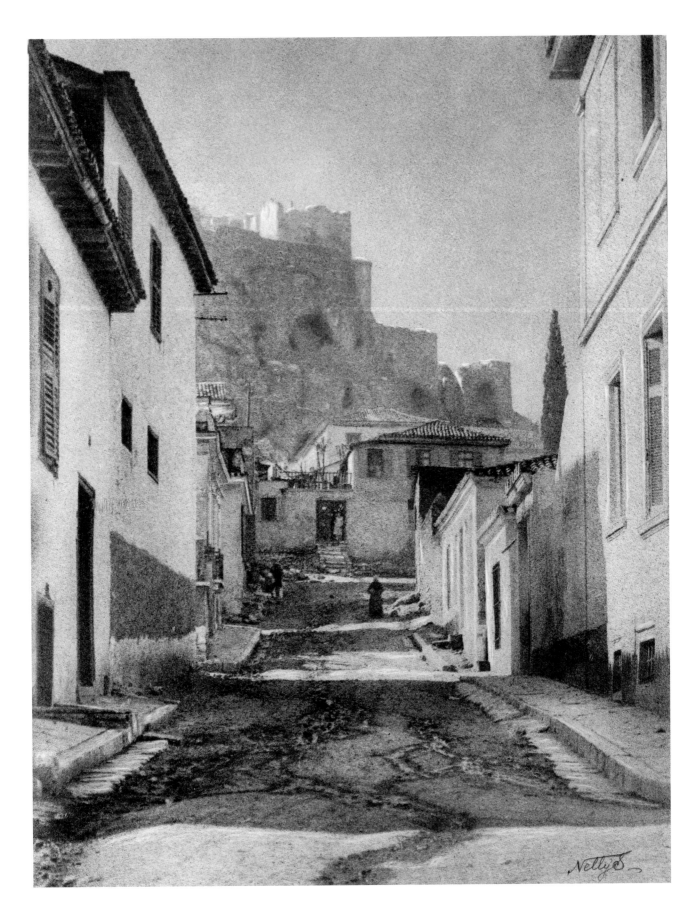

16 Dioskouron street in the old city of Athens, with the Acropolis in the background
Straße in der Altstadt von Athen mit Blick auf die Akropolis, 1927–29

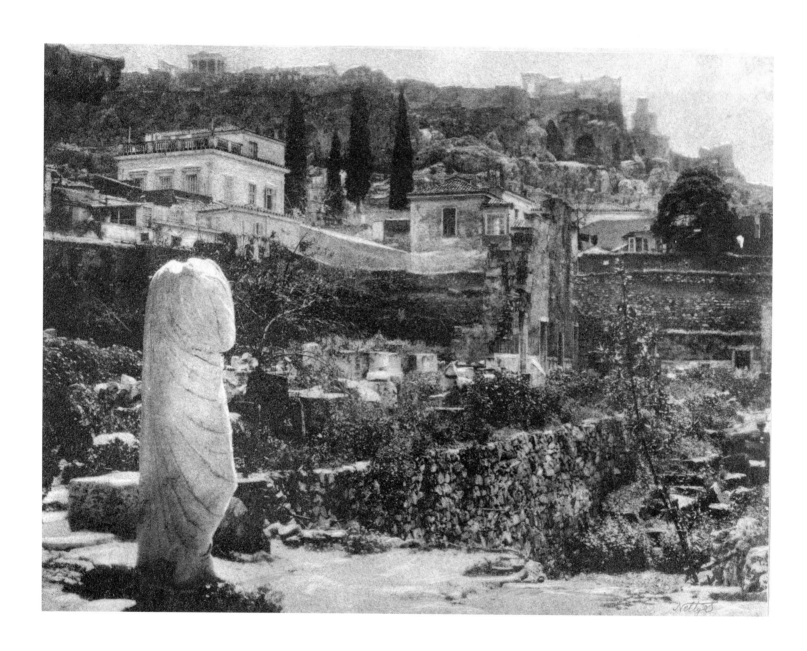

17　The ruins of the stoa of Attalus in the area of the ancient Agora with the Acropolis in the background
Die Ruinen der Attalos-Stoa auf der ehemaligen Agora mit der Akropolis im Hintergrund, 1927–29

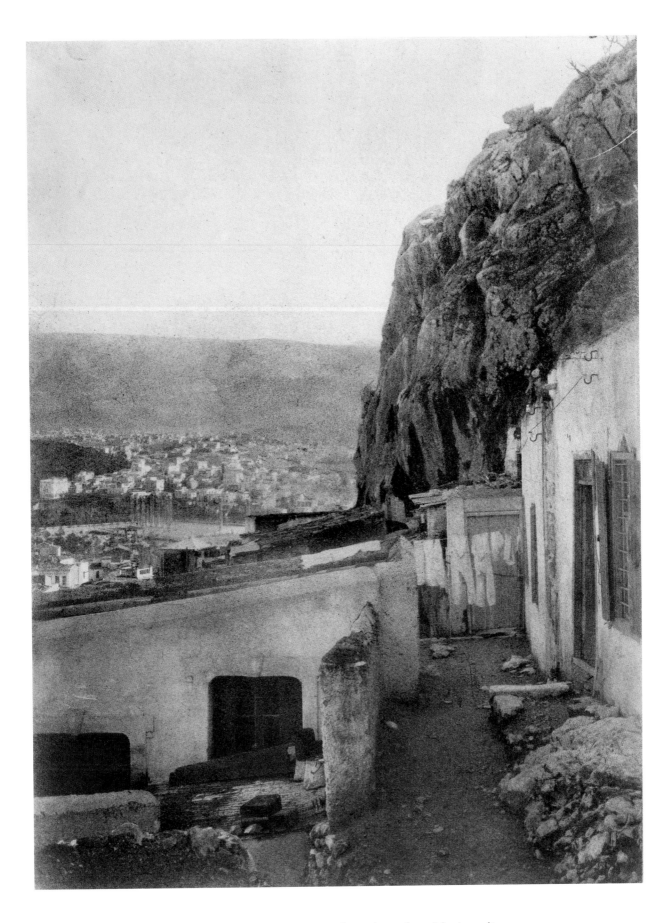

18 Houses in the Anafiotika quarter on the north-east slope of the Acropolis
Häuser im Stadtviertel Anafiotika nordöstlich der Akropolis, 1927–29

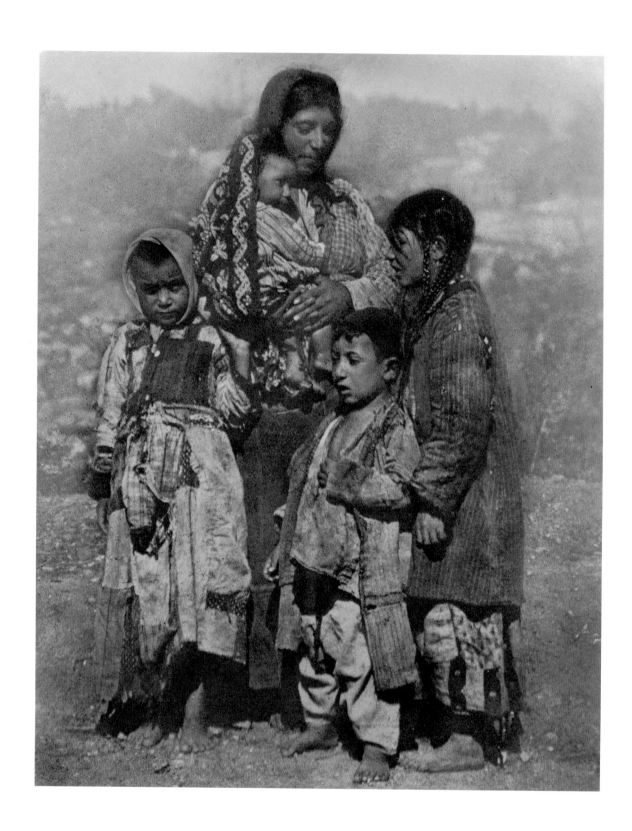

19 Greek refugees from Asia Minor / Griechische Flüchtlinge aus Kleinasien, 1925–27

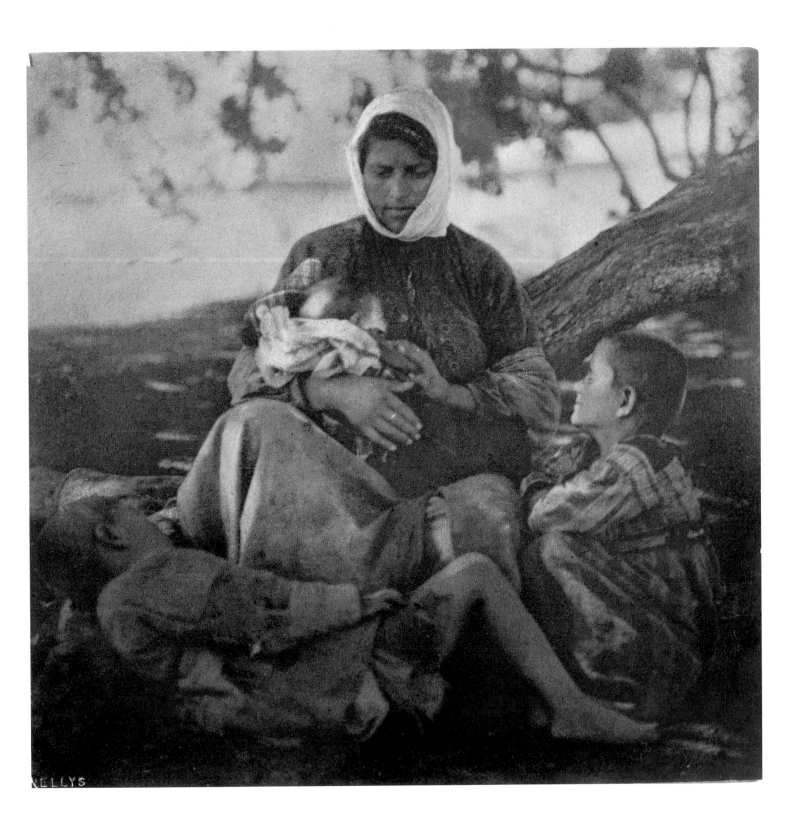

20 Greek refugees from Asia Minor / Griechische Flüchtlinge aus Kleinasien, 1925–27

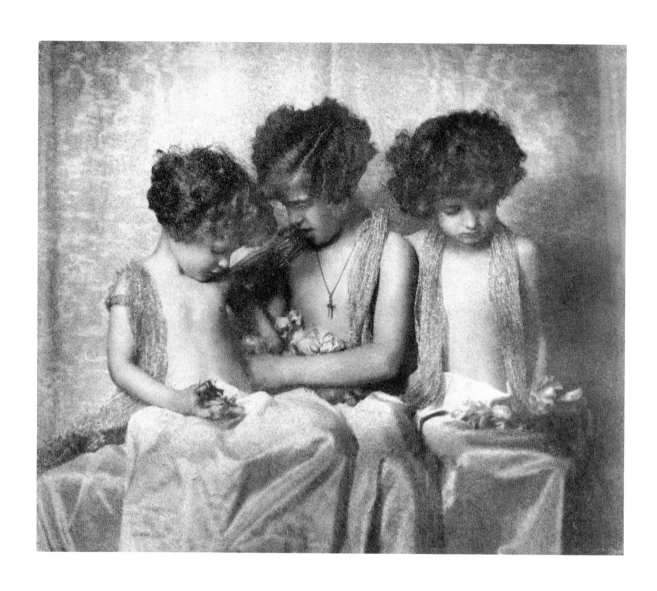

21 The children of the Koumantaros family
Die Kinder der Familie Koumantaros, late 1920s

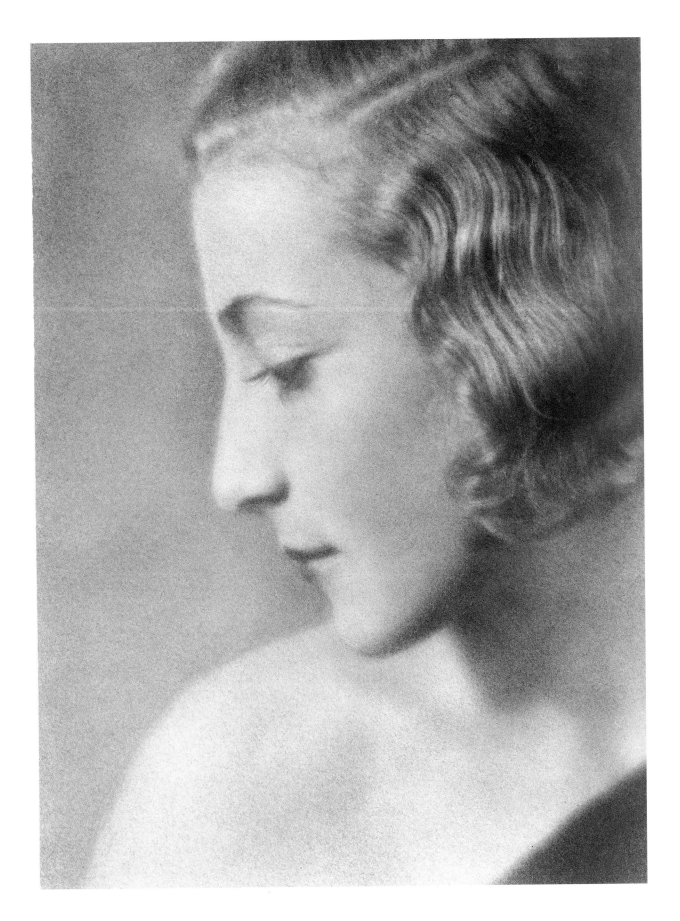

22 Portrait of a woman / Frauenporträt, late 1920s

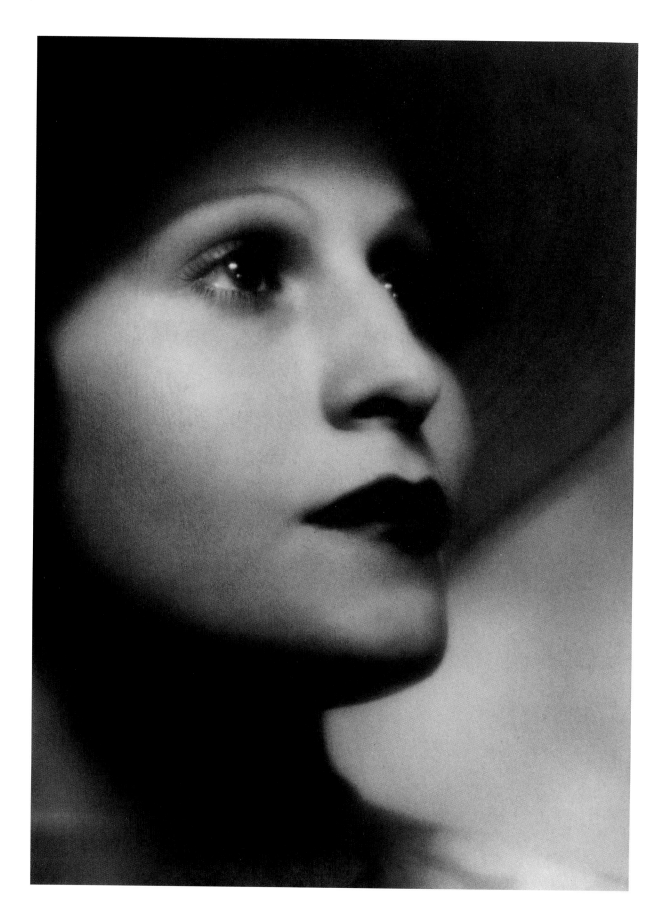

23 Portrait of a woman / Frauenporträt, 1930s

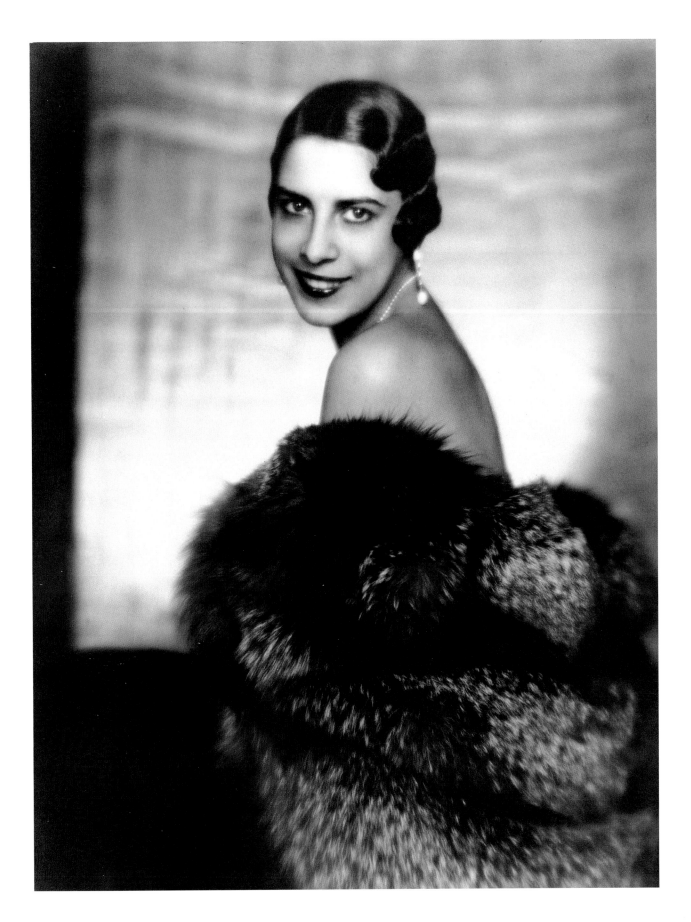

24 Portrait of Mrs. Retsina / Porträt von Madame Retsina, 1930s

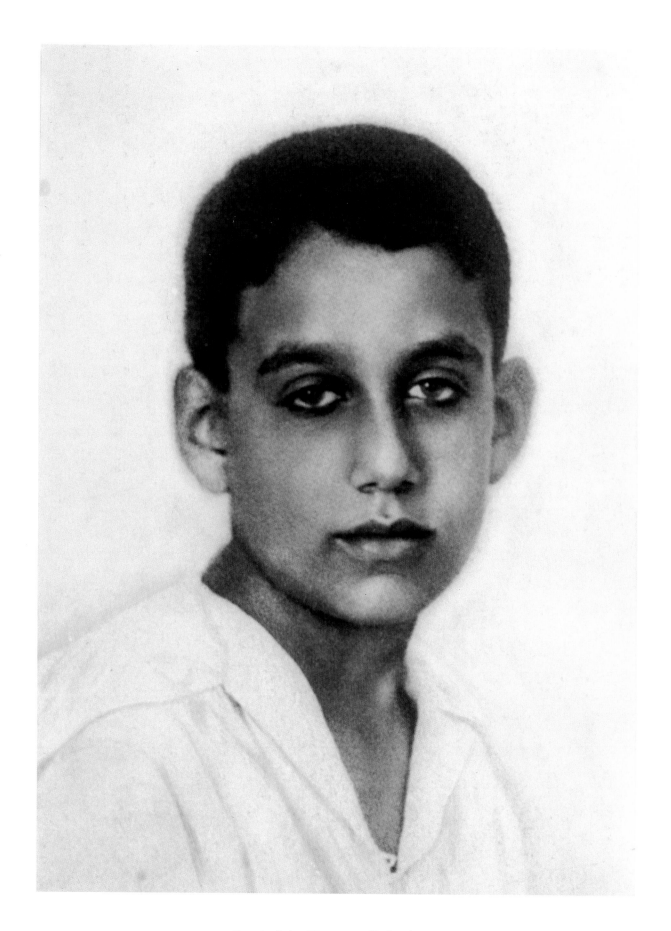

25 Portrait of a boy / Porträt eines Knaben, late 1920s

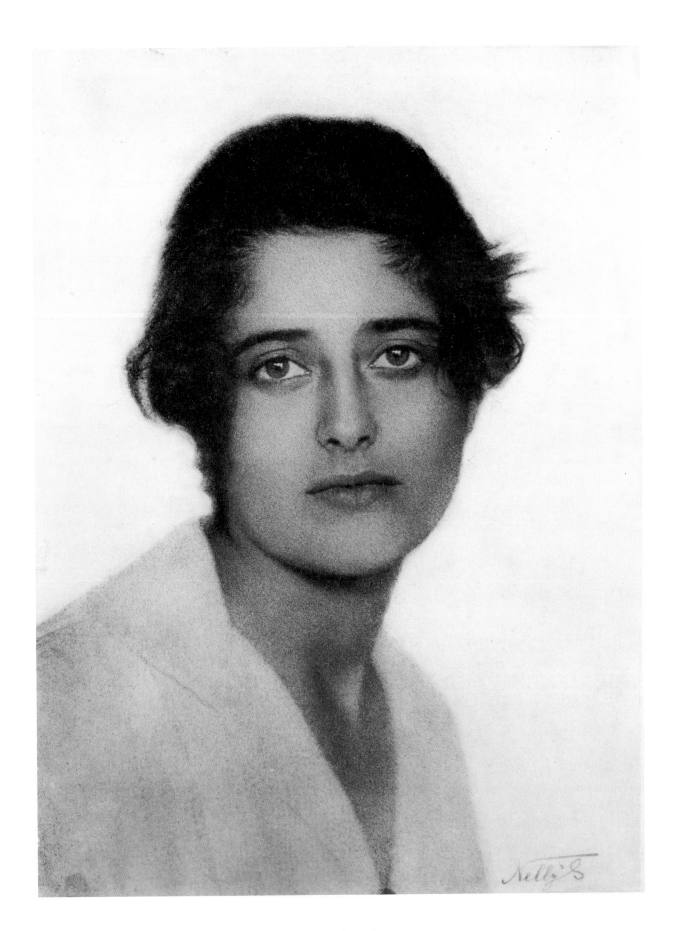

26 Riga Iliopoulou, early 1920s

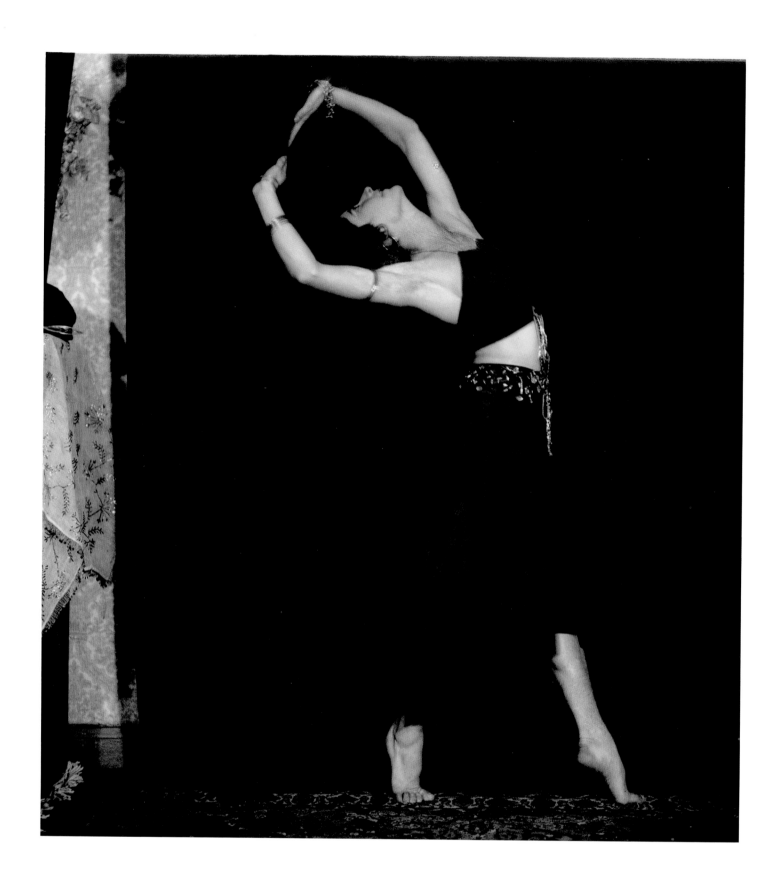

27 Mona Paiva in Nelly's studio / Mona Paiva in Nellys Atelier, 1927

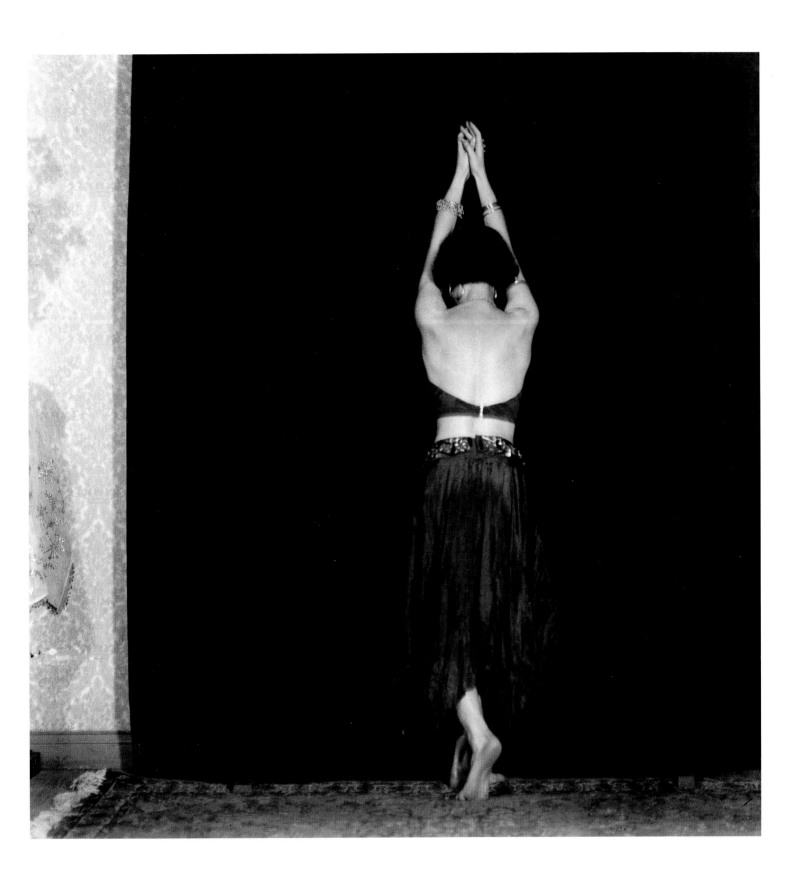

28 Mona Paiva in Nelly's studio / Mona Paiva in Nellys Atelier, 1927

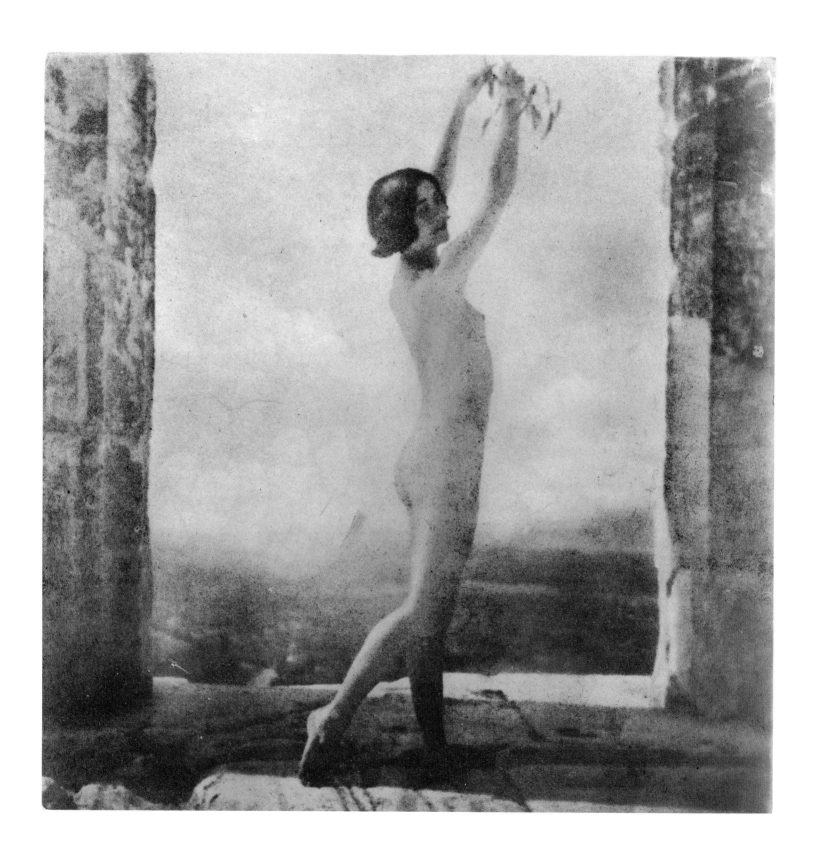

29 The dancer Mona Paiva on the Acropolis
Die Tänzerin Mona Paiva auf der Akropolis, 1927

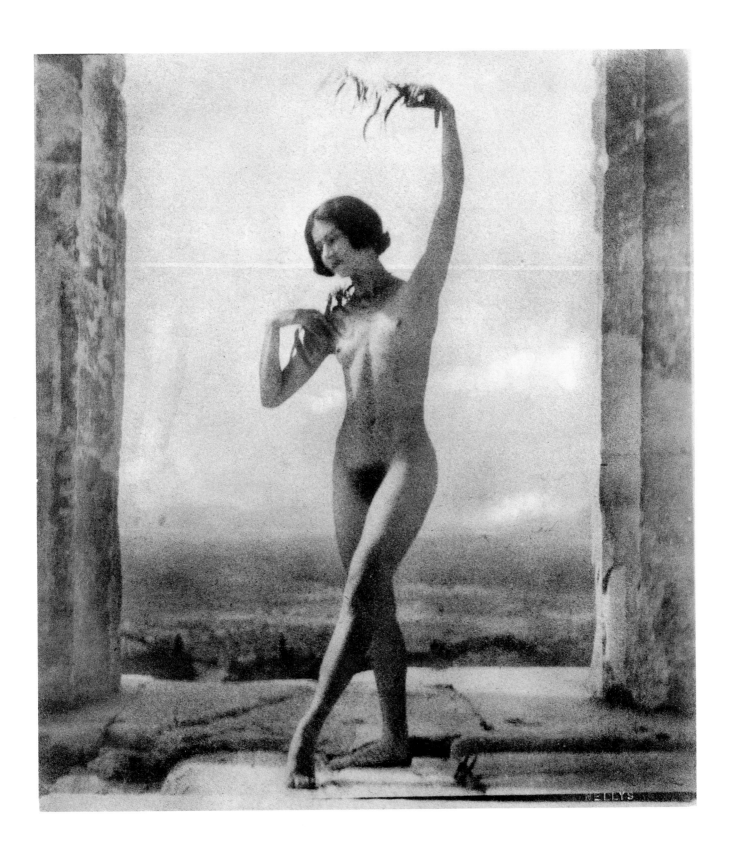

30 The dancer Mona Paiva on the Acropolis
Die Tänzerin Mona Paiva auf der Akropolis, 1927

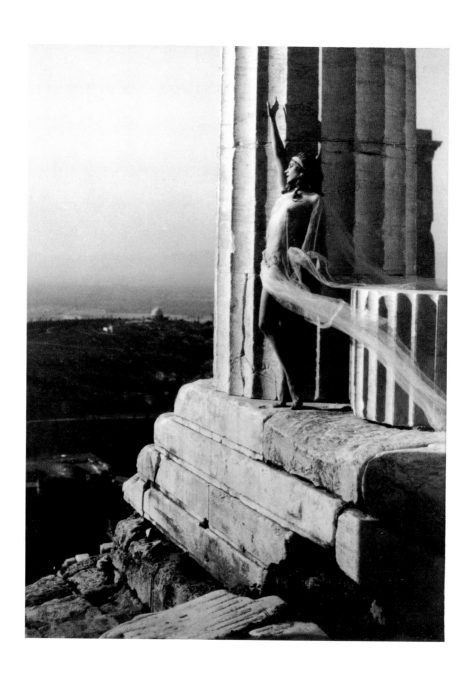

31 The dancer Nikolska in the Propylaea
Die Tänzerin Nikolska in den Propyläen, 1929

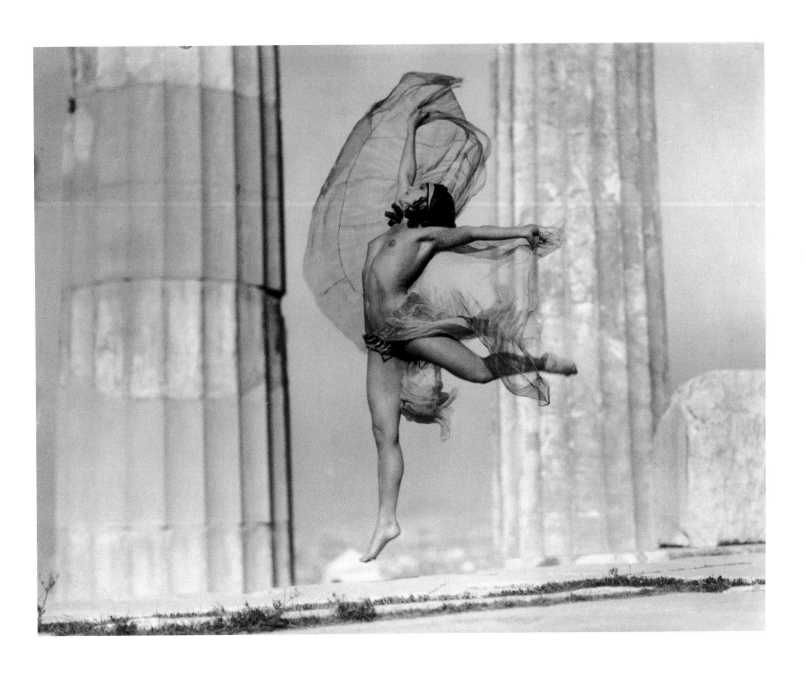

32 The dancer Nikolska in the Parthenon
Die Tänzerin Nikolska im Parthenon, 1929

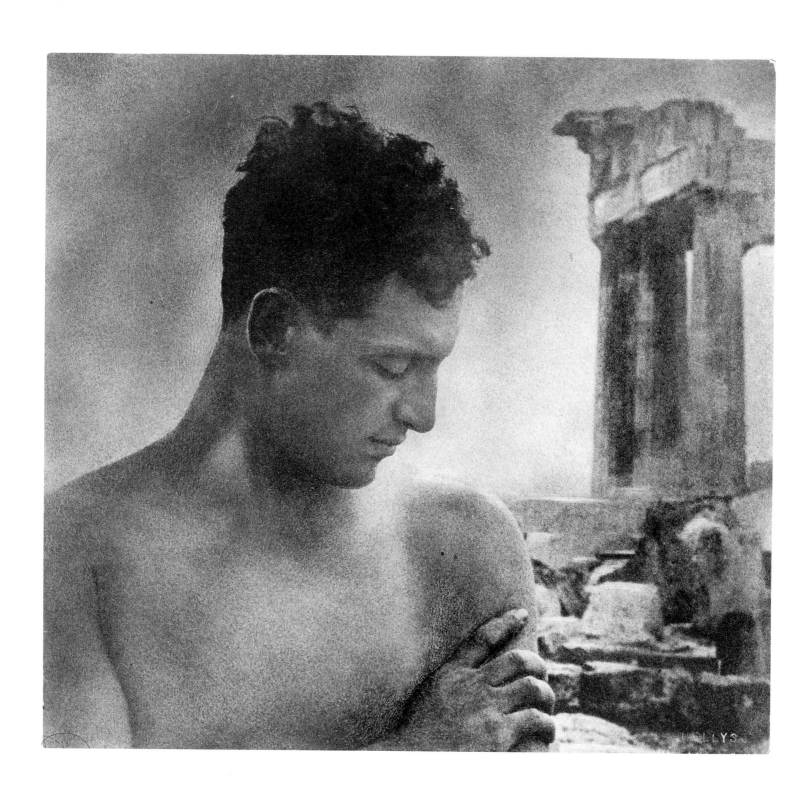

33 The athlete Dimitris Karabatis on the Acropolis
Der Sportler Dimitris Karabatis auf der Akropolis, 1925

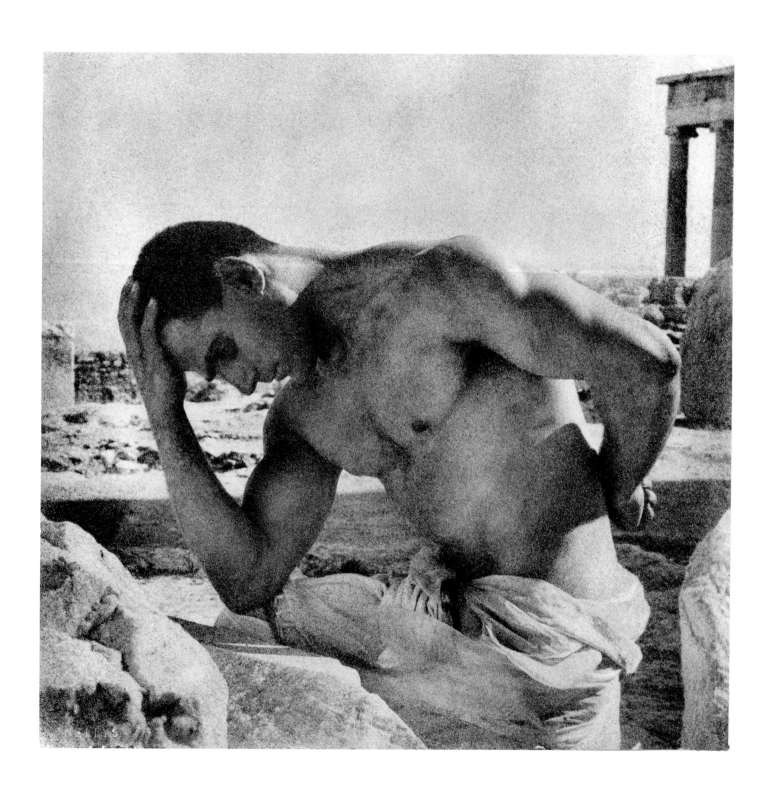

34 Athlete on the Acropolis
Sportler auf der Akropolis, 1925

35 Propylaea / Propyläen, late 1920s

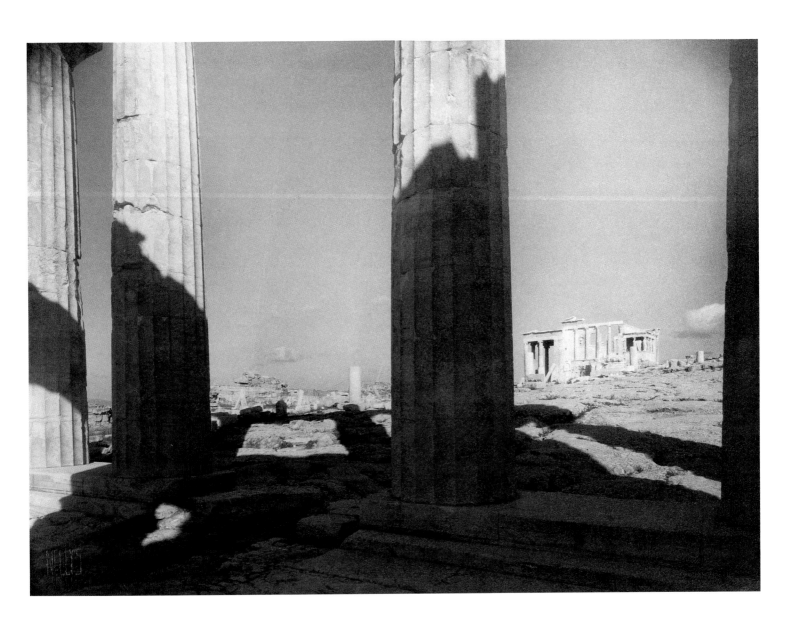

36 View of the Erechtheion from the Propylaea
Blick von den Propyläen auf das Erechtheion, 1930

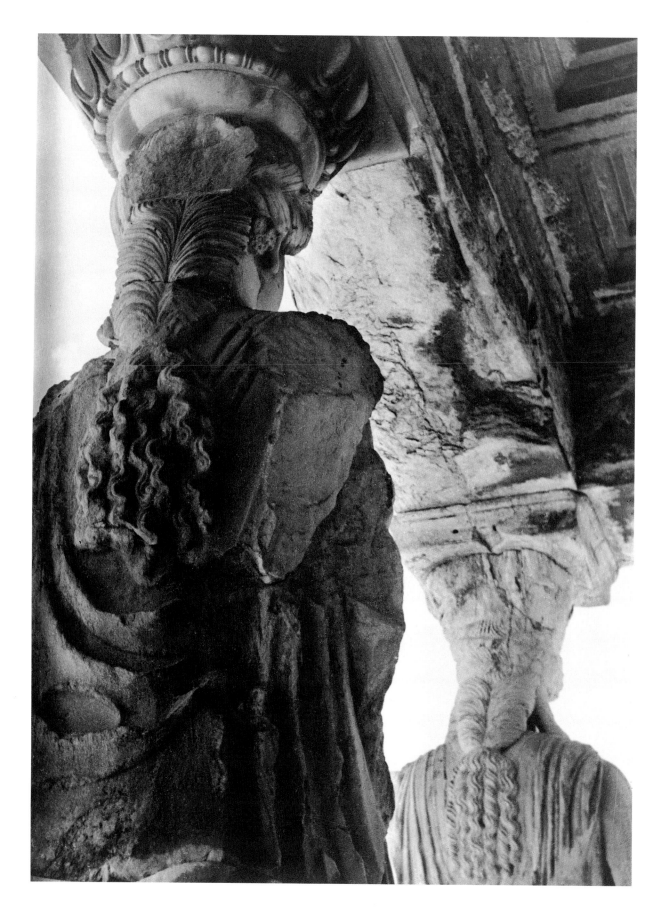

37 The Caryatids of the Erechtheion / Die Karyatiden des Erechtheion, 1930

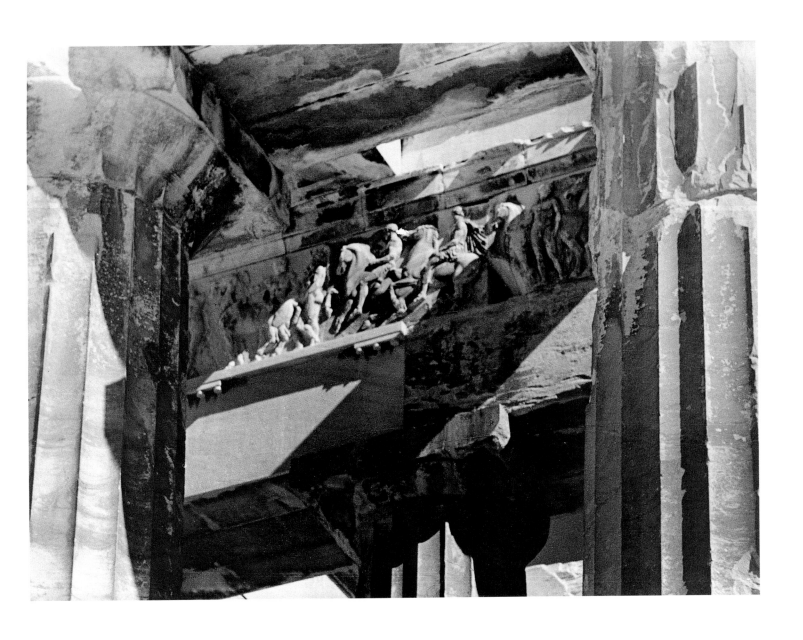

38　Part of the western Parthenon frieze
Teil des westlichen Parthenonfrieses, 1930

39 Olympia—the entrance to the stadium / Eingangstor zum Stadion von Olympia, late 1920s

40　Ancient ruins at Olympia / Ruinenfeld in Olympia, 1927

41 Head of Alexander the Great
Kopf Alexanders des Großen, 1930

42 Heracles and the lion of Nemea, metope from the Temple of Zeus in Olympia
Herakles und der Löwe von Nemea, Metope vom Zeustempel in Olympia, late 1920s

43 Cretans / Kreter, late 1920s

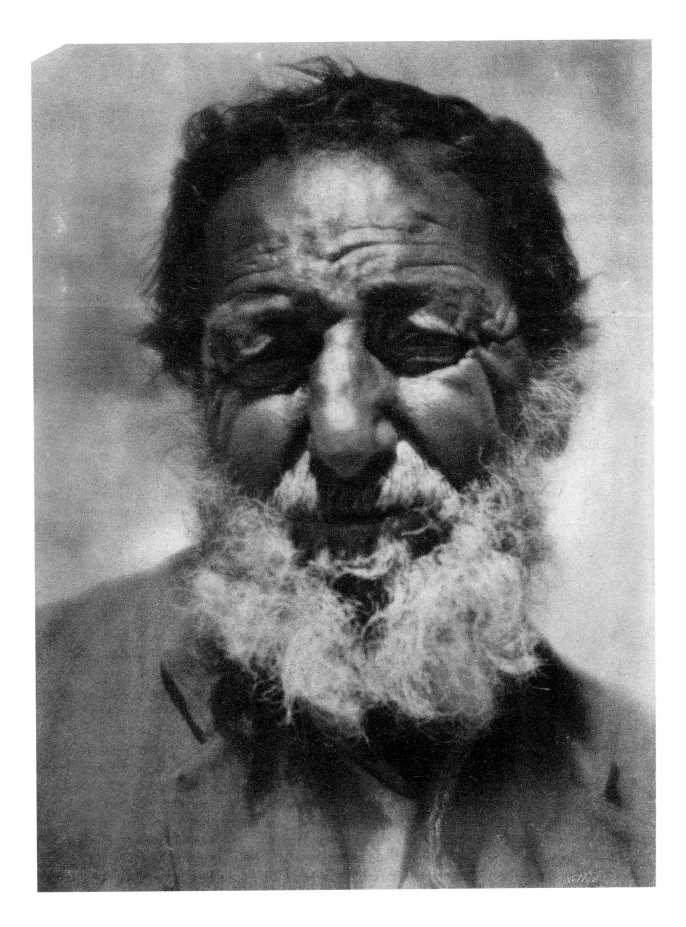

44 Portrait of an old man / Porträt eines alten Mannes, late 1920s

45 Trees / Bäume, late 1920s

46 Trees / Bäume, late 1920s

NEW YORK
1939–1966

47 Skyscraper / Wolkenkratzer, c. 1970

48–51 Collages for the World Fair in New York / Collagen für die Weltausstellung in New York, late 1930s

52 Skyscrapers / Wolkenkratzer, c. 1950

53 Skyscraper / Wolkenkratzer, c. 1950

54 Skyscraper / Wolkenkratzer, c. 1950

55 Skyscrapers / Wolkenkratzer, c. 1950

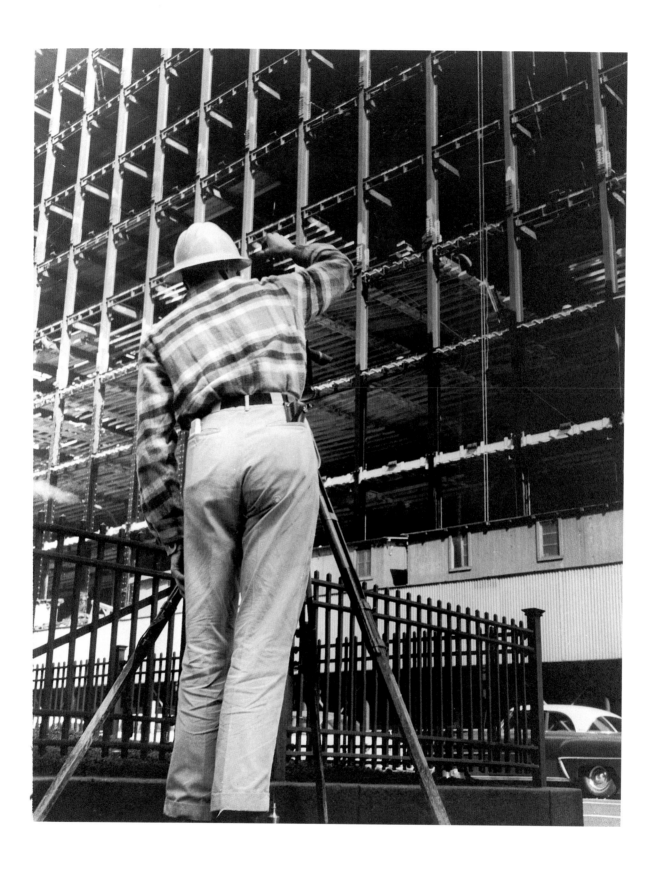

56 Building a skyscraper / Bau eines Wolkenkratzers, c. 1950

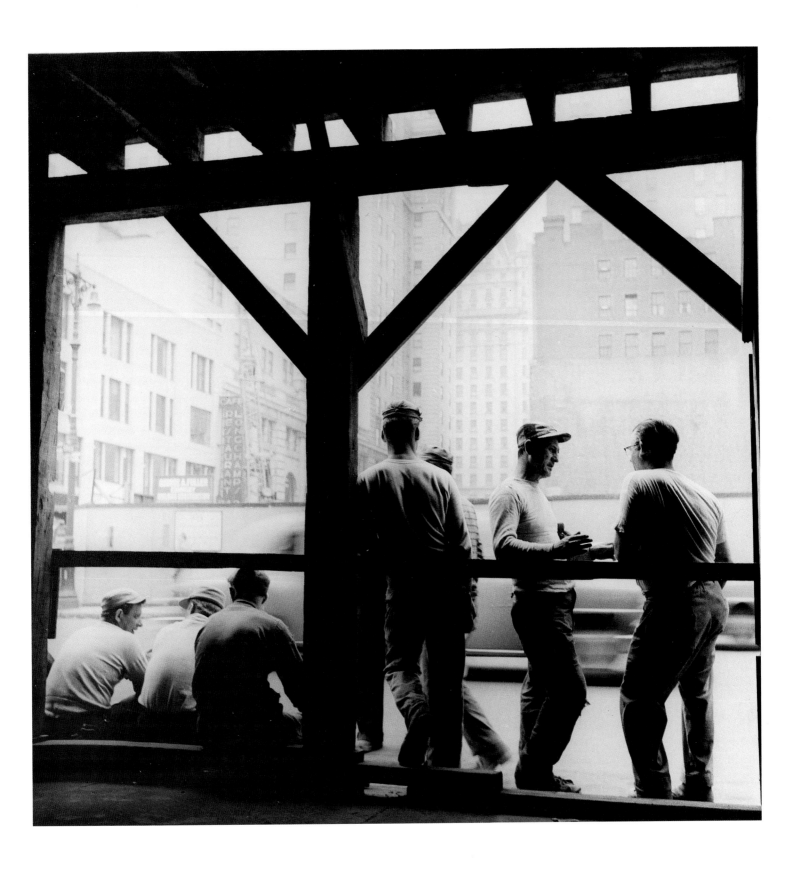

57 Workers at rest / Arbeiter in der Pause, c. 1950

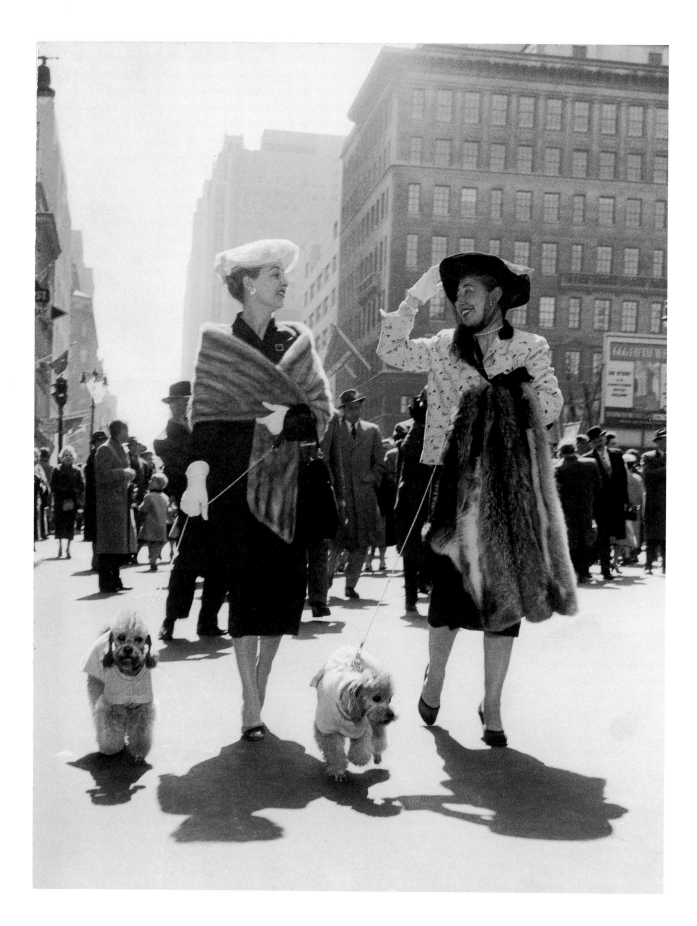

58 From the *Easter Parade* series / Aus der Serie *Easter Parade*, c. 1950

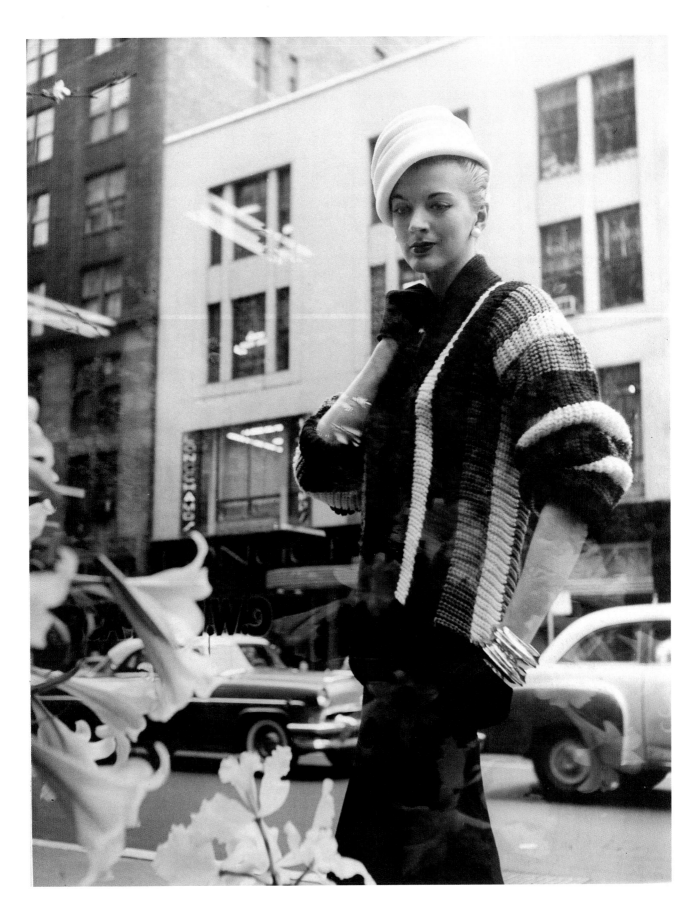

59 Shop window—from the *Easter Parade* series
Das Schaufenster – Aus der Serie *Easter Parade*, c. 1950

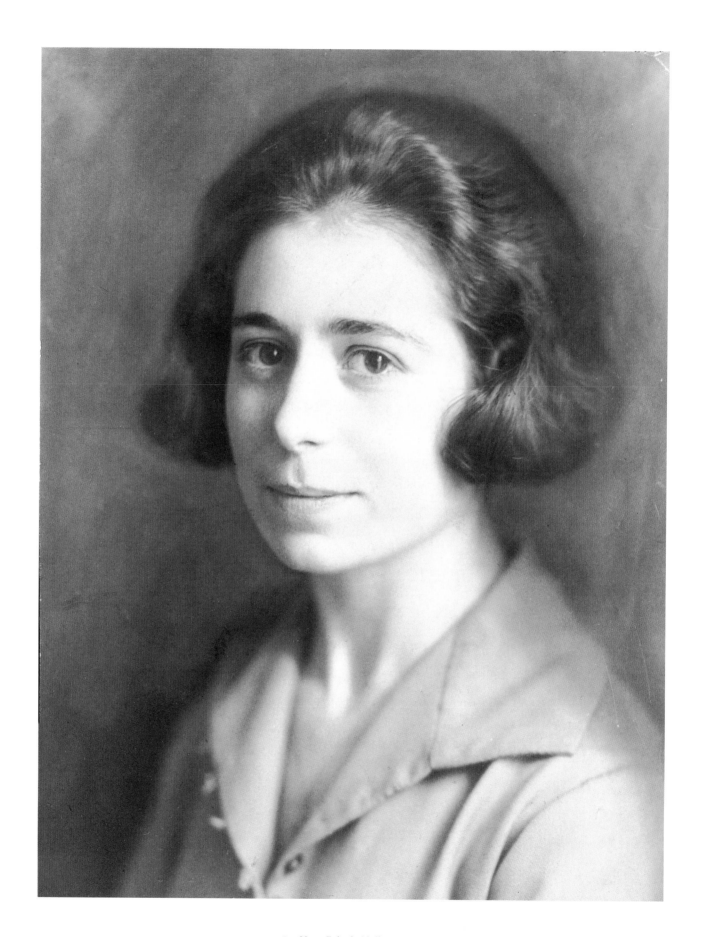

60 Hugo Erfurth, Nelly, 1923

"There Is Only One Greece"

An Interview with Nelly, conducted by Matthias Harder [1]

Matthias Harder: Mrs. Seraidaris, you have now lived in Athens for almost thirty years. This is the longest period that you ever spent continuously in Greece.

Nelly: Thirty years already? I can hardly believe it. There was one reason for my long absence: the Second World War. My husband and I traveled to America in 1939 for just three weeks. We decorated the Greek pavilion at the World Fair. That was at the end of August, and the war began a couple of days later. We heard of the massacres in Europe, and we grew fearful of returning. I recalled the great misfortune that had been visited earlier upon my own country. So we stayed in New York—until 1966.

Was it difficult for you to establish yourself as a photographer in the United States? Did you end up feeling like an American, after a few years?

No, I never felt like an American. The whole time I wanted to go back to Greece. At first it was very rough. We had almost no money. But I soon found customers in the Greek community. A few shippers also helped me at the time. Gradually I became better known, and I organized various shows. Also, during the war I held lectures about photography and about Greece.

Your first solo show in America was held in the summer of 1940 at the James O'Toole Gallery in New York.

That gallery had never before put on a photo show. But they decided to do it as soon as they saw my pictures. Normally we would have had to pay rent on the space, but the gallery handled that, too, and they also took over the interior design, printed the invitations and sent them out at their own cost. The show was a big success. Many, many people came to see my pictures, including people from Columbia University and other institutions.

How did you meet the gallerist in the first place?

I went to an exhibition of painting at his gallery, and I invited him to my studio. That was when he decided to also show photographs at his space.

The guest list reads like a "Who's Who" of American high society. The show was held under the patronage of the Greek general consul in New York. Was it also a financial success?

No. I did not sell a single photo. I never planned to, because I

»... Griechenland ist einzigartig«.

Nelly im Gespräch mit Matthias Harder [1]

Matthias Harder: Frau Seraidaris, Sie leben inzwischen fast dreißig Jahre in Athen, die längste Periode, die Sie durchgehend in Griechenland verbracht haben.

Nelly: Dreißig Jahre schon – ich kann es kaum glauben. Meine lange Abwesenheit hatte einen Grund: der Zweite Weltkrieg. Mein Mann und ich fuhren 1939 eigentlich nur für drei Wochen nach Amerika, um den griechischen Pavillon auf der Weltausstellung zu bestücken. Das war Ende August, ein paar Tage später begann der Krieg. Als wir von den Massakern in Europa hörten, bekamen wir Angst zurückzukehren. Ich erinnerte mich an all das Unglück in meiner Heimat, das früher geschehen war. So blieben wir in New York – bis 1966.

War es schwierig für Sie, auch in Amerika als Photographin erfolgreich zu sein? Fühlten Sie sich nach einigen Jahren als Amerikanerin?

Nein, als Amerikanerin fühlte ich mich nie; ich wollte die ganze Zeit zurück nach Griechenland. Zunächst war es sehr hart; wir hatten so gut wie kein Geld. Aber ich fand bald eine Kundschaft in der griechischen Gemeinde. Auch einige Reeder halfen mir damals. Langsam wurde ich bekannter und organisierte verschiedene Ausstellungen. Zusätzlich hielt ich während des Krieges auch Vorträge über Photographie und über Griechenland.

Ihre erste Einzelausstellung in Amerika hatten Sie im Sommer 1940 in der New Yorker Galerie von James O'Toole.

Diese Galerie hatte nie zuvor eine Photoausstellung ausgerichtet. Doch als sie meine Bilder sahen, wollten sie sie zeigen. Normalerweise hatte man für die Raummiete zu zahlen, aber auch die haben sie übernommen, ebenso den Aufbau, den Druck der Einladungskarten und deren Versand. Die Ausstellung war ein großer Erfolg; sehr viele Besucher, darunter Angehörige der Columbia University und anderer Institutionen, kamen, um meine Bilder zu sehen.

Und wie hatten Sie den Galeristen kennengelernt?

Ich besuchte eine Ausstellung von Gemälden in seiner Galerie und lud den Galeristen zu mir ein. So entschied er sich, auch Photographie in seinen Räumen zu präsentieren.

Die Gästeliste liest sich wie ein ›who is who‹ der gehobenen amerikanischen Gesellschaft, und sie stand unter dem Patro-

wanted to take the complete show to other locations. I mainly lived off commissions for portraits.

In the photography collection at the Benaki Museum, I discovered your stills of ancient Greek architecture, which had stamps of your New York studio on the reverse. Did you reprint these photos in America to supply shows, or to sell them there?

Both. I sold a few of these photos in America, whereas others I showed multiply or made available to magazines.

Nowadays no collector has a chance of buying any of your pictures.

Many people would like to have photos by me. But I have donated all of them to the Benaki Museum, and I kept only a few selected pictures for myself. They are hanging right here, in my home.

Your first portraits of Benaki family members date back to the 1920s. Was that a factor in your donation to the museum, or were there other reasons for choosing the Benaki Museum to preserve your archives?

When I die, I will like to think that my photos are in a safe place. I am convinced that the museum will give photos to serious parties. My work will live on. Also, it will not be isolated, because the works of many Greek photographers are brought together at the Benaki Museum. My connection to the Benakis did not just come through the portraits I took of them. It was Delta, the sister of Adonis Benakis, who in the 1920s successfully revived the Delphic Games, and she commissioned me to photograph this event.

The curators of the Benaki Museum photographic collection will maintain your archive and organize shows of your work in Greece and other countries. How many photos did you donate to the museum?

I don't know. I didn't count. It was thousands of negatives and stills.

And until the donation you kept your entire archive in New York, and later here, in the apartment in Nea Smirni?

Yes. Before, all of the material was in my apartment. I was afraid that if I died, everything would end up spread all over the place.

Before your exhibition in America, you also showed your photos of Greece in Athens. Did you also show them in Germany?

I had a lot of shows in Greece, and not just in my studio, but none until now in Germany.[2]

Your pictures were first published in Germany. Your dance photography appeared in a German publication seventy years ago, and also in a 1924 book called Ideale Körper-Schönheit. *Do you still have a copy?*

Ideale Körper-Schönheit, of course. I had the book, but unfortunately it was stolen. I asked Dr. Dewitz from Agfa Foto-Histora-

nat des griechischen Generalkonsuls. War die Bilderschau auch finanziell ein Erfolg?*

Nein, ich habe kein einziges Photo verkauft. Das war auch nicht meine Absicht, denn ich wollte die gesamte Ausstellung auch an anderen Orten zeigen. Ich lebte in erster Linie von den Porträtaufträgen.

In der Photographischen Sammlung des Benaki-Museums habe ich Ihre Aufnahmen antiker griechischer Architektur entdeckt, die auf der Rückseite mit Ihrem New Yorker Studiostempel versehen waren. Haben Sie diese Photos in Amerika neu abgezogen, um Ausstellungen beliefern oder sie verkaufen zu können?

Beides. Einige dieser Photos habe ich in Amerika verkauft, andere wiederum habe ich mehrfach ausgestellt oder Magazinen zur Verfügung gestellt.

Inzwischen kann aber kein Sammler mehr Bilder von Ihnen erwerben.

Viele Leute würden gerne Photos von mir haben. Aber ich habe alle dem Benaki-Museum geschenkt und nur ein paar ausgewählte Bilder für mich zurückbehalten. Sie hängen hier in der Wohnung.

Bereits in den zwanziger Jahren haben Sie einige Angehörige der Benaki-Familie porträtiert. War das ausschlaggebend für Ihre Schenkung, oder gab es auch andere Gründe dafür, dieses Museum für die Pflege Ihres Archivs auszuwählen?

Wenn ich sterbe, möchte ich meine Photos an einem sicheren Ort wissen. Ich bin überzeugt, daß das Museum die Bilder an seriöse Interessenten weitergeben wird. So bleibt mein Werk lebendig. Es steht dort ja auch nicht allein, viele griechische Photographen sind in der Sammlung des Benaki-Museums vereint. Eine Verbindung zu den Benakis bestand also nicht nur über die Porträts, die ich von ihnen gemacht habe. Delta, die Schwester von Adonis Benakis, bemühte sich Ende der zwanziger Jahre erfolgreich, die Delphischen Spiele wiederzubeleben, und vermittelte mir den Auftrag, dieses Ereignis zu photographieren.

Die Kuratoren der Photographischen Sammlung des Benaki-Museums werden Ihr Archiv pflegen und bewahren sowie Ausstellungen im In- und Ausland organisieren. Wieviele Photos ungefähr haben Sie dem Museum überlassen?

Das weiß ich nicht. Ich habe sie nicht gezählt; es waren Tausende von Negativen und Abzügen.

Hatten Sie bis zur Übergabe Ihres Archivs alle Aufnahmen in New York und später hier in Ihrer Wohnung in Nea Smirni?

Ja, zuvor lag das ganze Material in meiner Wohnung. Ich hatte Angst, wenn ich sterbe, daß alles überallhin verteilt würde.

Vor Ihrer Ausstellung in Amerika zeigten Sie Ihre Griechenlandaufnahmen in Athen – stellten Sie auch in Deutschland aus?

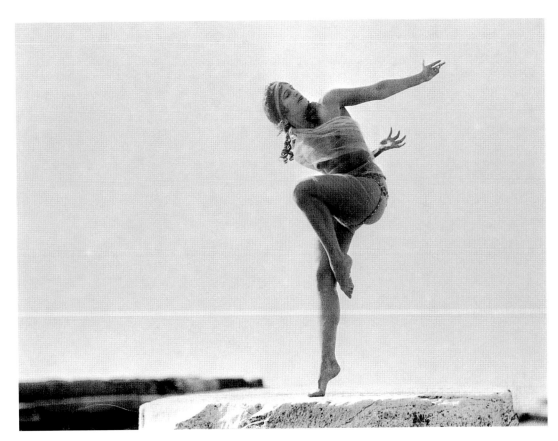

Nikolska on the Acropolis
Nikolska auf der Akropolis, 1929

ma to look for this book in Germany. I would be very happy to get a copy, because it is the first book in which a few of my photos were published.

It included Bromoil pictures by colleagues of yours, like Franz Fiedler.
It didn't just include the oil pigment prints. Depending on the subject, there were also photos of Mary Wigman's pupils dancing, photos of nudes. And Franz Fiedler was also in the book.

Dance and nudes. That was a classic combination, in 1920s photography. Was your teacher, Hugo Erfurth, an important influence in this regard?
No, during my two years under Erfurth I exclusively studied portraiture and the photographic reproduction of paintings. I remember taking stills of paintings by Dix and Kokoschka. Later, I became Fritz Fiedler's right hand. Whenever we photographed dancers he would let me develop the material, because he trusted me and my work. Finally he started sending me out with the models alone, and that is when I did the nude photos in Saxon Switzerland.

Why did you switch from Erfurth to Fiedler?
Well, I completed my studies with Erfurth after two years. Fiedler's studio in Dresden was near my apartment at the time.

In Griechenland hatte ich sehr viele Ausstellungen, nicht nur in meinem Studio, in Deutschland bisher noch keine.[2]

Aber die erste Veröffentlichung Ihrer Bilder erfolgte doch wohl in Deutschland. Bereits vor über siebzig Jahren waren Ihre Tanzphotographien in einer deutschen Publikation vertreten, 1924 in dem Buch Ideale Körper-Schönheit. *Haben Sie noch ein Exemplar dieses Buches?*
Ideale Körper-Schönheit, ja natürlich. Ich besaß das Buch, doch leider wurde es mir gestohlen. Ich habe bereits Dr. Dewitz vom Agfa Foto-Historama gebeten, in Deutschland nach diesem Bildband zu suchen. Ich wäre sehr glücklich, es wiederzubekommen, weil es das erste Buch ist, in dem ich einige meiner Photos veröffentlicht habe.

Es waren darin ja auch Bromölbilder von Kollegen wie Franz Fiedler aufgenommen.
Es waren nicht nur Edeldruckverfahren vertreten; in Bezug auf das Sujet waren es insbesondere Tanzphotographien von Schülerinnen der Mary Wigman und Aktphotographien. Und Franz Fiedler war auch vertreten.

Tanz und Akt. Das war eine klassische Kombination in der Photographie der zwanziger Jahre. War in dieser Beziehung ihr Lehrer Hugo Erfurth prägend?

91

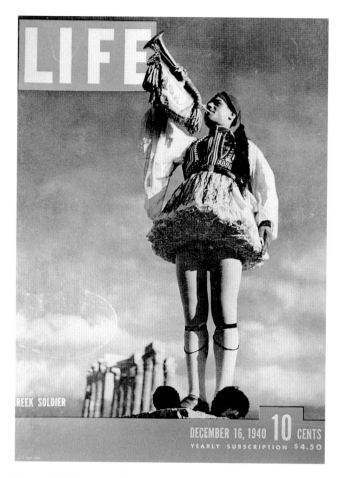

LIFE

GREEK SOLDIER

DECEMBER 16, 1940 **10** CENTS
YEARLY SUBSCRIPTION $4.50

Cover of LIFE magazine / Umschlag von LIFE, 1940

In the first year, I suffered terribly on the long way to Erfurth's studio during the cold of winter. That was the worst frost in sixty years, but I went anyway, so I would never miss a lesson.

Who accompanied you to Dresden, back then?
I went to Dresden with my brother. He wanted to study engineering at the Technical University. But his German was not good enough. He had trouble following the lessons. A very good friend of my father's, the Greek consul, supported us.

Before your training in photography, you first studied painting and music in Dresden.
Yes, with the Italian painter Simonson-Castelli, a very big name at the time. Every museum and every gallery had his pictures. He lived in the top floor of the villa of our friend, the consul, who introduced him to me.

After a short time you switched from painting to photography. What was the reason?
Our country went through two catastrophes. My family was driven out of Aidini and lost nearly everything. After the "Disaster of Smyrna," I did not even know at first what had hap-

Nein, bei Erfurth habe ich in der zweijährigen Ausbildungszeit nur das Porträtieren erlernt und das photographische Reproduzieren von Gemälden. So machte ich beispielsweise Aufnahmen von Bildern von Dix und Kokoschka. Später wurde ich die rechte Hand von Franz Fiedler. Wenn wir Tänzerinnen photographierten, gab er mir das Material zum Entwickeln, denn er vertraute mir und meiner Arbeit. Schließlich schickte er mich mit den Modellen alleine los, so entstanden die Aktaufnahmen in der Sächsischen Schweiz.

Warum wechselten Sie von Erfurth zu Fiedler?
Zunächst weil ich meine Ausbildung nach zwei Jahren bei Erfurth beendete. Fiedlers Studio lag in der Nähe meiner damaligen Wohnung in Dresden. Im ersten Jahr litt ich sehr unter dem weiten Weg zu Erfurths Atelier und der großen Kälte im Winter. 60 Jahre lang hatte es keinen so strengen Frost gegeben, aber ich ging hin, um keine Unterrichtsstunde zu versäumen.

Wer begleitete Sie damals nach Dresden?
Ich ging mit meinem Bruder nach Dresden. Er wollte an der Technischen Universität Ingenieurwesen studieren. Doch seine Kenntnisse der deutschen Sprache waren kaum ausreichend; er konnte dem Unterricht nur schwer folgen. Ein sehr guter Freund von meinem Vater, der griechische Konsul, unterstützte uns.

Vor Ihrer photographischen Ausbildung hatten Sie doch in Dresden zunächst Malerei und Musik studiert.
Ja, bei dem damals sehr bekannten italienischen Maler Simonson-Castelli; jedes Museum und jede Galerie hatte Bilder von ihm. Er wohnte bei dem befreundeten Konsul in der obersten Etage der Villa und wurde mir durch ihn vorgestellt.

Nach kurzer Zeit wechselten Sie von der Malerei zur Photographie. Was war der Grund?
Es gab zwei Katastrophen in meiner Heimat. Meine Familie hatte durch die Vertreibung aus Aidini beinahe alles verloren. Nach der ›Katastrophe von Smyrna‹ wußte ich zunächst nicht, was mit ihnen geschehen ist. In dieser Situation dachte ich, selbst wenn ich die Kunstausbildung fortführte, würde doch kein zweiter Rembrandt aus mir. Ich besuchte in Dresden neben Malerei- auch Photoausstellungen; mir gefiel die Photographie. Ich sagte mir, nach einer praktischen Ausbildung – und später als Porträtphotographin – könnte ich meiner Familie am besten helfen. Das war der Grund, zu wechseln.

Warum entschieden Sie sich Anfang der zwanziger Jahre überhaupt für Deutschland?
Ich hörte von vielen Leuten, besonders von Künstler-

pened to them. In this situation, I thought that even if I could continue my art education, I would never be a second Rembrandt. In Dresden, in addition to painting, I was also visiting photo shows, and I liked photography. I told myself that I could help my family best if I took practical training and became a portrait photographer. That was the reason to change.

Why did you choose Germany in the first place, in the early 1920s?
I had heard from many people, especially artist friends, that it was the best place to learn the most.

And you went to Dresden, instead of Berlin or Munich, both of which had very active art scenes in the early 1920s.
My friends told me that Dresden was the best place.

In Dresden, you must have heard about Bauhaus, which had its center nearby in Weimar, and about the photographic experiments of Moholy-Nagy. Didn't you have any ambitions to study there, at least for a semester?
Yes, I heard about Bauhaus. But nobody had told me about the photography there, so I never came up with the idea of going there.

Your classical training in photography has shaped your life's work. Were you not interested in photographic experiments?
No. First of all, I wanted to learn the craft and return to Greece, to work here, to open a photo studio, to support my family financially.

And that is exactly what happened. Your photo studio ultimately became very well known, and you were visited by a number of photographers. Did you also meet the two German photographers of Greece, Herbert List and Walter Hege?
Yes, both came to my studio, as did many other photographers. A few then took up my own style of photography, like the famous American photographer Hoyningen-Huene.[3]

You made portraits of your compatriots and you traveled often, across the whole country. What was the difference between studio and open-air work?
Of course I did the job whenever I was commissioned to do a portrait, but every time I caught a glimpse of the clouds in the sky, I would try to arrange these shoots outside. Or I would ask my husband Angelos to do it. Next to the Acropolis I was especially interested in medieval Athens, with its small churches and original architecture. I felt compelled to photograph the Plaka, at least to keep a record of it in pictures before everything disappeared. I developed the photos as Bromoil prints and showed them in my studio. An author with one of the big Athenian newspapers wrote a long article about this exhibition, at which point a famous Greek historian proposed to me that he and I should do a systematic survey of old Athens and record it

freunden, daß man dort am besten und am meisten lernen könnte.

Und Sie entschieden sich für Dresden – und gegen Berlin oder München, die zu Beginn der zwanziger Jahre eine höchst lebendige Kunstszene hatten.
Meine Freunde sagten mir, Dresden sei der beste Ort.

In Dresden hörten Sie sicherlich vom Bauhaus, das in Weimar, ganz in der Nähe, angesiedelt war, und von den photographischen Experimenten eines Moholy-Nagy. Hatten Sie keine Ambitionen dort zu studieren, möglicherweise für ein Semester?
Ja, ich habe vom Bauhaus gehört. Aber niemand hatte mir damals etwas von der Photographie dort erzählt, so kam ich auch nicht auf die Idee, dorthin zu gehen.

Sie haben eine klassische Photoausbildung genossen, was Ihr gesamtes Werk prägt. Haben Sie sich nicht für photographische Experimente interessiert?
Nein. In erster Linie wollte ich das Handwerk lernen und nach Griechenland zurückkehren, um hier zu arbeiten, ein Photostudio zu eröffnen und meine Familie finanziell zu unterstützen.

So geschah es dann ja auch. Ihr Photostudio wurde im Laufe der Zeit sehr bekannt, es besuchten Sie dort auch einige Photographen. Begegneten Ihnen auch die beiden deutschen Griechenlandphotographen Herbert List und Walter Hege?
Ja, beide kamen in mein Studio und viele andere Photographen. Einige folgten dann meiner Art zu photographieren, wie der berühmte amerikanische Photograph Hoyningen-Huene.[3]

Sie porträtierten ihre Landsleute, und sie reisten viel durchs Land. Wie war das Verhältnis zwischen Studio- und Freiluftaufnahmen?
Wenn ich wichtige Porträtaufträge hatte, erfüllte ich diese natürlich, aber immer wenn ich Wolken am Himmel sah, versuchte ich draußen zu photographieren – oder bat meinen Mann Angelos, es zu tun. Neben der Akropolis interessierte mich insbesondere das mittelalterliche Athen mit den kleinen Kirchen und der ursprünglichen Architektur. So mußte ich die Plaka photographieren, um diesen Zustand zumindest im Bild zu erhalten, bevor alles verschwinden würde. Ich arbeitete die Bilder als Bromöldrucke aus und präsentierte sie in meinem Studio. Ein Autor einer der größten Athener Zeitungen schrieb einen längeren Artikel über diese Ausstellung, woraufhin ein berühmter griechischer Historiker mir vorschlug, mit ihm gemeinsam das alte Athen regelmäßig und systematisch zu besuchen und aufzunehmen.[4] So entstand eine große Bildserie, die allerdings erst jetzt publiziert werden soll, hoffentlich noch dieses Jahr.

in pictures.[4] We took a huge set of pictures, but it is only about to be published this year, I hope.

Were these your last Bromoil photos?

No, I used that technique well into the 1930s. Oil pigment printing was my favorite technique, my passion ever since the time I spent in Dresden. My Bromoil prints of the dancers in Saxon Switzerland were especially treasured by Mary Wigman. Her verdict made me very happy at the time, and I am still proud of it today.

Was your training in Germany important to the development of your work and visual technique?

Oh, yes, it was very important. The kind of training you had with Erfurth or Fiedler was impossible in the Greece of that time. I really enjoyed my time with them.

Your study of painting is surely reflected in the choice of oil pigment print techniques. Were the Bromoil prints in effect a synthesis of the two media?

Yes, you could say that. First I learned about painting, and then I gave myself the task of coloring my photographs. I was very curious about the changes that you could make. Only a few colleagues were producing color Bromoils. Franz Fiedler showed me the procedure step by step, and he entrusted me with his studio key. I worked constantly in his darkroom, especially on Sundays when I had nothing else to do. I blew up various shots twice the size and then colored them in different shades. Fiedler was thrilled. You could really say he was proud of my experiments.

You first began to experiment in your work again in New York. Were your slanted views of the skyscrapers there inspired by the work of fellow photographers like Berenice Abbott?

No, I did not know her at the time. I thought I was the only one who had ever taken such shots! Often I was interested mainly in the form itself, and I tried to contrast the foreground with the background.

Looking back, what do you today consider your most important period of work?

I don't know. I always tried to create something different. I was interested in many things. My colleagues like my child portraits, the portraits of women and fashion photos and also the other subjects. Most photographers tend to specialize in narrow fields, but I worked in all areas. In New York I also attended courses in photojournalism with a very famous man at the time, from Harper's Bazaar.[5] The concept he assigned to us, for a small photo story we were supposed to do, was just this: Fantasy. On Easter Sunday, I took my Rolleiflex and my Leica and I went to a church near my studio on 57th Street, to photograph people as they came out, also just people on the street and the pretty storefront windows at Tiffany's. I took a great many pictures in a

Waren dies Ihre letzten Bromölbilder?

Nein, ich verwendete die Technik bis weit in die dreißiger Jahre. Edeldruckverfahren waren meine bevorzugte Technik, meine Passion seit meiner Zeit in Dresden. Meine Bromölbilder der Tänzerinnen in der Sächsischen Schweiz wurden von Mary Wigman besonders geschätzt. Dieses Urteil machte mich damals sehr glücklich, und ich bin auch heute noch stolz darauf.

War Ihre Ausbildungszeit in Deutschland wichtig für die Entwicklung Ihrer Bildsprache und Ihres Werkes?

Ja, sie war sehr wichtig. Eine solche Ausbildung wie bei Erfurth oder Fiedler war in Griechenland zu der Zeit nicht möglich. Ich habe die Zeit sehr genossen.

Ihre Malerei-Ausbildung spiegelt sich sicherlich auch in der Wahl der photographischen Edeldruckverfahren wider. Waren die Bromöldrucke gewissermaßen eine Synthese beider Medien?

Ja, so könnte man es nennen. Ich hatte die Malerei kennengelernt, und nun stellte ich mir die Aufgabe, meine Photographien zu kolorieren. Ich war sehr neugierig auf das so veränderte Edeldruckverfahren. Nur wenige Kollegen stellten kolorierte Bromöldrucke her. Franz Fiedler zeigte mir die Arbeitsschritte und vertraute mir seinen Studioschlüssel an. In der dortigen Dunkelkammer arbeitete ich sehr fleißig, insbesondere an Sonntagen, an denen ich sonst nichts zu tun hatte. So vergrößerte ich ausgewählte Motive zweimal und kolorierte sie anschließend unterschiedlich. Fiedler war begeistert, ja man kann sagen: er war stolz auf meine Experimente.

Experimentell haben Sie erst wieder in New York gearbeitet. Sind Ihre Schrägansichten der Hochhausarchitektur durch Kollegen wie Berenice Abbott inspiriert?

Nein, ich kannte sie damals nicht. Ich dachte, ich allein hätte solche Aufnahmen gemacht. Mich interessierte häufig die bloße Form; und ich arbeitete mit dem Motivkontrast von Vorder- und Hintergrund.

Was halten Sie selbst im Rückblick für Ihre wichtigste Werkphase?

Ich weiß es nicht. Stets versuchte ich etwas Unterschiedliches zu schaffen; ich war an vielen Dingen interessiert. Meine Kollegen schätzen meine Kinderbilder, die Frauenporträts, die Mode und auch die anderen Sujets. Die meisten Photographen sind sehr spezialisiert, ich arbeitete dagegen auf allen Gebieten. In New York besuchte ich auch Kurse über Photojournalismus bei einem damals sehr berühmten Mann von Harper's Bazaar.[5] Er gab uns einen Begriff, zu dem wir eine kleine Bildgeschichte entwerfen sollten: Phantasie. Am Ostersonntag nahm ich meine Rolleiflex und meine

very short time, and this turned into my "Easter Parade" series. The course instructor praised the results very highly and suggested publishing it, but that only happened much later, after my show in the Alpha-Delta gallery in Athens.

Your photographs of Greece were the most successful in the United States. These were exhibited and published often, and also bought by museums. Do you feel like a patriot?
I do feel that way, but there is much more to it than that. There is only one Greece, there is nothing like it anywhere else. Already in my childhood, in Asia Minor, my father told me many stories about Greece, and he passed his love for this country on to me.

Leica und photographierte in der Nähe meines Studios in der 57. Straße die Menschen, die aus der Kirche kamen, die Passanten und die schönen Schaufensterauslagen von Tiffany's. Ich machte sehr schnell sehr viele Bilder, so entstand meine *Easter Parade*-Serie. Der Kursleiter lobte mein Arbeitsergebnis sehr und schlug vor, es publizieren zu lassen, was allerdings erst viel später, nach meiner Ausstellung in der Galerie Alpha-Delta in Athen, geschah.

Den größten Erfolg hatten Sie in Amerika mit Ihren Griechenlandphotographien; sie wurden nicht nur ausgestellt und vielfach publiziert, sondern auch von Museen angekauft. Fühlen Sie sich als Patriotin?
So fühle ich mich tatsächlich, doch es ist noch mehr. Griechenland ist einzigartig, nichts vergleichbares existiert irgendwo anders. Bereits in meiner Kindheit in Kleinasien hat mir mein Vater viele Geschichten über Griechenland erzählt und mir seine Liebe für dieses Land weitergegeben.

1 Parts of this interview, which was held in Athens in October 1995, were published previously in: "Chronika im Gespräch: Elli Seraidari (Nelly's)," Chronika. Monatszeitung für griechische Kultur, Berlin (Ioannou), III:1, Jan. 1996, pp. 8ff.
2 Photos by Nelly were included in a 1990 show called "Searching for the Land of the Greeks with the Soul" at the Agfa Foto-Historama in Cologne, and in "Photography Meant Participation," a 1994 show at the Museum Folkwang in Essen on female photographers in the Weimar Republic. The present volume is meant to accompany a retrospective of about 80 photographic works by Nelly, which she shot in German-speaking countries at different times over a period of four decades.
3 Hege and List may well be the most important German photographers of Greece. Hege went on photo tours of the country in 1928 and 1935, List in 1937. Both visited Nelly's studio in Athens. Hege published a series of large books full of Greek photos starting in 1930. George Hoyningen-Huene published his book of Greek photos in 1943, and List followed with a book in 1953.
4 Nelly refers here to the historian Dimitrios Kambouroglou, who later wrote the text for their joint book on old Athens, *Nelly's: I palaia polis ton Athinon* (Nelly's: The Old City of Athens), (Athens: Gnosi, 1996).
5 Nelly refers here to Alexej Brodovitch, the influential New York art director with various fashion magazines.

1 Das Interview fand im Oktober 1995 in Athen statt und wurde 1996 in der Zeitschrift Chronika in Auszügen veröffentlicht: ›Chronika im Gespräch: Elli Seraidaris (Nelly's)‹ in Chronika. Monatszeitung für griechische Kultur, Berlin: Ioannou, III/1, Januar 1996, S. 8ff.
2 Nelly beteiligte sich 1990 und 1994 an den Ausstellungen ›Das Land der Griechen mit der Seele suchen‹ im Kölner Agfa Foto-Historama und ›Fotografieren hieß teilnehmen. Photographinnen der Weimarer Republik‹ im Museum Folkwang Essen. Nellys erste Retrospektive mit etwa 80 Arbeiten aus vier Jahrzehnten im deutschsprachigen Raum ist Anlaß für die vorliegende Publikation.
3 Hege und List können als bedeutendste deutsche Griechenlandphotographen gelten; sie bereisten 1928 und 1935 bzw. ab 1937 das Land. In diese Zeit fallen auch die Besuche in Nellys Atelier. Hege veröffentlichte seit 1930 mehrere umfangreiche Griechenlandbildbände, George Hoyningen-Huene folgte ihm 1943, List 1953 mit je einer Publikation ihrer Griechenlandphotographien.
4 Nelly meint in diesem Zusammenhang den Historiker Dimitrios Kambouroglou, der später den Begleittext für ihr gemeinsames Buch über das alte Athen verfaßte, *Nelly's. I palaia polis ton Athinon*, Athen: Gnosi, 1996.
5 Nelly spricht hier über Alexej Brodovitch, den einflußreichen New Yorker Art Director verschiedener Modemagazine.

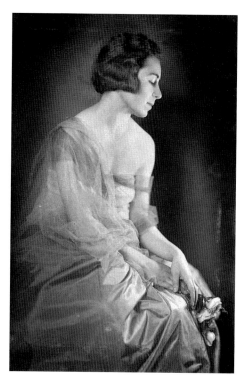

Nelly's second studio in Athens on 21, Hermou Street / Nellys zweites Atelier in Athen

Hugo Erfurth, Nelly, 1920s

Franz Fiedler, Nelly, after completing her studies
Nelly bei Abschluß ihres Studiums

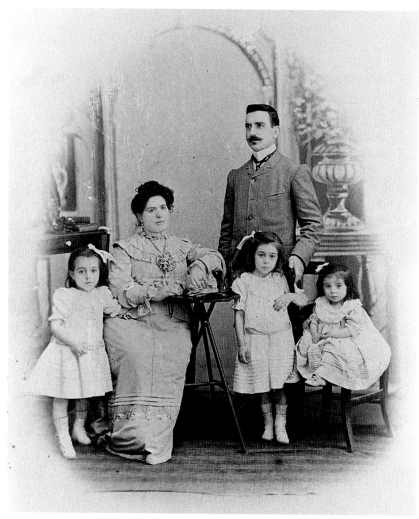

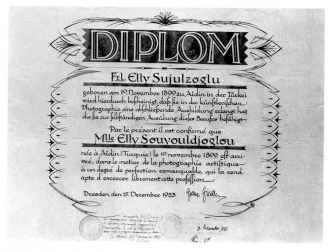

Nelly's diploma / Nellys Diplom

The Seraidaris family, Nelly is standing in front of her father, Aidini, Asia Minor
Die Familie Seraidaris, Nelly steht vor ihrem Vater, Aidini, Kleinasien, 1903

Angelos Seraidaris and Nelly's brother Nikos Sougioutzoglou / Angelos
Seraidaris und Nellys Bruder Nikos Sougioutzoglou

Biography

1899–1919

Elli Souyoultzoglou was born on November 23, 1899 in the Anatolian town of Aidini (today Aydin). The eldest of four children in a wealthy Greek merchant family, she attended a primary school run by French nuns, and from 1912 to 1917 she went to the Omireios girls' boarding school in the bustling harbor city of Smyrna (today Izmir). She was familiar with the nearby ancient Greek cities of Asia Minor, but Greece itself she knew only from her father's stories. The region of her birth was annexed in the spring of 1919 first by Italian and then by Greek forces, with major Allied troop movements around the Eastern Aegean at the end of World War I. Hostilities in the region cost the lives of hundreds of Greeks and Turks, civilians and soldiers alike. Following attacks by Turkish partisans, Nelly's family left Aidini for nearby Smyrna in September 1919.

1920–1923

In the winter of 1920, Nelly and her brother Nikos went to Dresden, where she wanted to study painting and music. She took courses with the Italian painter, Ernst Oskar Simonson-Castelli, who had started an art school in Dresden in 1897. She also took private piano lessons. Nelly switched subjects a year later, henceforth devoting herself to the study of portrait photography and pigment printing techniques, at first under Hugo Erfurth, and later under Franz Fiedler until late 1923. She and Fiedler collaborated in producing a series of nude and dance stills taken in the studio and outdoors. A selection of her work appeared in *Ideale Körper-Schönheit* (Ideal Body Beauty), a small-format volume published in 1924 by Vitus Verlag in Dresden.

The Treaty of Sèvres, reached in August 1920 to end hostilities in Asia Minor, foundered on the Greek side's willingness to continue the war with Turkey. Following the military defeat of Greek forces in the fall of 1922, Nelly's family fled Smyrna in advance of the Turkish forces, who plundered, murdered and deported the Greek and Armenian minorities.

1924–1926

Having completed her studies, in late 1924 Nelly rejoined her family in Athens, where they had found refuge. She opened a portrait studio in 1925 and quickly gained a large clientele

Biographie

1899–1919

Elli Souyoultzoglou wurde am 23. November 1899 als erstes von vier Kindern im anatolischen Aidini (heute: Aydın) geboren. Sproß einer wohlhabenden griechischen Kaufmannsfamilie, besuchte sie dort zuerst eine von französischen Nonnen geführte Schule und von 1912 bis 1917 in Smyrna (heute: Izmir) das Mädchengymnasium Omireios als Internatsschülerin. Die nahen griechisch-antiken Städte in Kleinasien waren ihr bekannt, doch Griechenland selbst wurde ihr nur durch die Erzählungen ihres Vaters vermittelt. Im Frühjahr 1919 erfolgten Gebietsannexionen durch italienische und später durch griechische Truppen an der türkischen Westküste sowie größere alliierte Truppenverschiebungen in der Ostägäis. Es kam zu Schießereien, bei denen Hunderte von griechischen und türkischen Zivilisten und Soldaten starben. Nach türkischen Partisanenüberfällen zog Nellys Familie im September 1919 von Aidini in das nahe Smyrna.

1920–1923

Im Winter des Jahres 1920 ging Nelly mit ihrem Bruder Nikos nach Dresden, um dort Malerei und Musik zu studieren. Sie besuchte zunächst die Klasse des italienischen Malers Ernst Oskar Simonson-Castelli, der 1897 eine Kunstschule in Dresden gegründet hatte. Parallel nahm sie private Klavierstunden. Ein Jahr später wechselte sie das Fach und ließ sich von Hugo Erfurth und anschließend, bis Ende 1923, von Franz Fiedler in der Porträtphotographie und verschiedenen Edeldruckverfahren ausbilden. In Gemeinschaftsarbeit entstanden Akt- und Tanzaufnahmen im Atelier und im Freien, die in einer Auswahl 1924 in dem kleinformatigen Bildband *Ideale Körper-Schönheit* veröffentlicht wurden (Vitus-Verlag, Dresden).

Der Friedensvertrag von Sèvres im August 1920 war am griechischen Kriegswillen gescheitert. So mußte Nellys Familie nach der militärischen Niederlage der griechischen Truppen in Kleinasien im Herbst 1922 aus Smyrna vor den Türken fliehen, die die griechische und armenische Minderheit beraubten, ermordeten oder vertrieben.

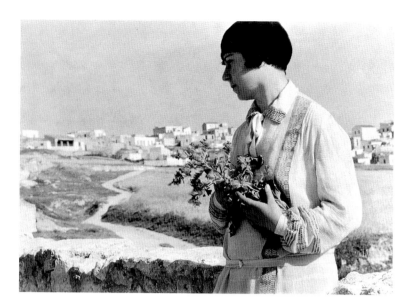

Franz Fiedler, Nelly, Greece / Griechenland, 1925

Nelly and Aristotle Onassis / Nelly mit Aristoteles Onassis,
New York, 1950

1924–1926

Nach ihrer Ausbildung zog Nelly Ende 1924 nach Athen,
wo inzwischen auch ihre Familie lebte. 1925 eröffnete sie im
Stadtzentrum ein Porträtatelier. Sie hatte mit Porträts von
wohlhabenden Athener Bürgern schon bald Erfolg und
konnte so ihre eigene Familie, die durch die Flucht beinahe
mittellos war, finanziell unterstützen. Das kleine Atelier in
der Ermou-Straße diente ihr auch als Ausstellungsort. So
zeigte sie hier die Bromöldruck-Serie der griechischen
Flüchtlinge aus den Jahren 1925–26. Neben den Studiopor-
träts photographierte sie die antike Architektur Athens, ins-
besondere die Akropolis, sowie die Häuser der Plaka, der
Altstadt am Fuße des Burgberges. Mit dem namhaften Histo-
riker Dimitrios Kambouroglou plante sie ein Buch über die
mittelalterliche Wohnarchitektur Athens, das jedoch erst
1996, mit fast siebzigjähriger Verspätung, erscheinen sollte.

1927–1929

Ab 1927 unternahm Nelly mehrere Reisen durch das touri-
stisch noch völlig unerschlossene Griechenland. Sie porträ-
tierte ihre Landsleute bei der Arbeit oder bei Volksfesten
und photographierte Landschaften. 1927 entstand eine Bil-
derserie während der ersten delphischen Festspiele. Zurück
in Athen photographierte sie 1927 die Tänzerin Mona
Paiva, damals Primaballerina der Pariser Opera Comique, im
Atelier und auf der Akropolis, nackt zwischen den Säulen
des Parthenon tanzend. Eines dieser Tanzbilder von Mona
Paiva erschien zwei Jahre später in der französischen Zeit-
schrift *Illustration*. Trotz der Entrüstung im konservativen
Athen entstanden 1929 Aktaufnahmen der ungarischen
Tänzerin Nikolska auf der Akropolis. Eines dieser Tanzbilder
wurde später ebenfalls publiziert. Im gleichen Jahr heiratete
Nelly den in Deutschland geborenen Pianisten Angelos
Seraidaris, den sie bereits 1923 in Dresden kennengelernt
hatte und der ihr später assistierte.

1930–1938

In den dreißiger Jahren wurde Nelly auch außerhalb Grie-
chenlands bekannt. Sie erhielt zahlreiche Aufträge, unter
anderem 1930 für eine exklusive Dokumentation der zweiten
Delphischen Festspiele. Als offizielle Photographin der neu-
gegründeten griechischen Presse- und Tourismusbehörde war
sie seitdem viel im Lande unterwegs und prägte mit ihren
Photographien das Griechenlandbild im Ausland. 1936 rei-
ste sie noch einmal, möglicherweise durch die Vermittlung
von Franz Fiedler nach Deutschland, um das neue Duxo-
chrom-Farbbildverfahren kennenzulernen. In Berlin besuch-

among wealthy Athenian citizens. Thus she supported her family, who had been left nearly penniless after their flight. Nelly's small studio on Ermou Street also served as a gallery for showing her Bromoil prints of Greek refugees, taken in the years 1925 and 1926. When she was not occupied at the studio, she busily photographed the ancient architecture of Athens, especially the Acropolis and the Plaka, the old medieval settlement at the foot of the ancient fortress. With the well-known historian Dimitrios Kambouroglou, Nelly planned a book on the residential architecture of medieval Athens, but their project was not published until 1996, seventy years later.

1927–1929

Starting in 1927, Nelly traveled extensively throughout Greece, which was still a virgin territory for tourists. She photographed landscapes, took portraits of her compatriots at work and at popular festivals, and shot a series of photos at the 1927 revival of the ancient Delphic festival and games. Back in Athens, in 1927 she photographed Mona Paeva, the prima ballerina of the Paris Opera Comique, in the studio and outdoors. A nude of Mona Paeva dancing between columns of the Parthenon was published two years later in the French magazine Illustration, provoking great indignation among conservative Athenians. This did not deter Nelly from shooting a further nude series on the Acropolis in 1929, this time of the Hungarian dancer Nikolska. That year, Nelly married the German-born Greek pianist Angelos Seraidaris, whom she had met in Dresden in 1923 and who later assisted her work.

1930–1938

During the 1930s, Nelly's photography gained prominence internationally. Among her many commissions, she was hired in 1930 to document the second staging of the Delphic Games, and she became the official photographer of the newly-founded Greek Ministry of Tourism. The photos she took on her many tours across the country began to shape the image of Greece abroad. In a trip apparently arranged by Franz Fiedler, she returned in 1936 to Germany, where she learned the new Duxochrome color photo process. She paid a visit to the Ufa film studios in Berlin and photographed the 1936 Olympic Games, but these color films were later lost. La mode grecque, the magazine of the Greek painter Nikos Engonopoulos, published a set of Nelly's fashion photographs in 1938.

1939–1965

Commissioned to decorate the Greek pavilion at the 1939 World Fair, Nelly duly traveled to New York, where she assem-

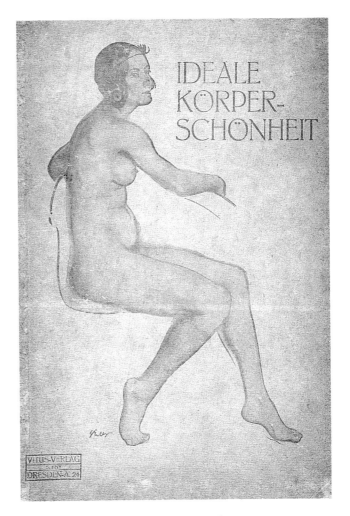

Ideale Körper-Schönheit, Cover / Umschlag, Dresden 1924

te sie das Filmgelände der Ufa und photographierte 1936 die Olympischen Spiele; die Farbaufnahmen gingen jedoch verloren.

1938 veröffentlichte sie Modephotographien in dem Magazin *La mode grecque*, das von dem griechischen Maler Nikos Engonopoulos herausgegeben wurde.

1939–1965

Für den griechischen Pavillon auf der Weltausstellung 1939 in New York montierte Nelly ihre Photographien zu großen Collagen. Thema war Griechenland in der Geschichte und in der Gegenwart. Ihr New York-Aufenthalt anläßlich der Weltausstellung sollte zunächst nur wenige Wochen dauern, bei Ausbruch des Zweiten Weltkriegs aber entschieden sich Nelly und ihr Mann Angelos Seraidaris bis auf weiteres in der amerikanischen Metropole zu bleiben. Der Neuanfang fiel ihnen nicht leicht, doch bald fanden sich Kunden in der

bled her photos into giant collages that presented the past and present of Greece. Her visit was only supposed to last a few weeks, but after the outbreak of World War II in Europe, she and her husband Angelos Seraidaris decided to remain in the United States. The new beginning was not easy for them, but they soon found patrons in the Greek community of New York City. Nelly opened a new studio in 1940 on 57th Street in Manhattan. Her stills of Greece were displayed at the James O'Toole Gallery in New York, Columbia University, and the Baltimore Museum of Art; several pictures were published in Life magazine, while others were bought by the Metropolitan Museum of Art in New York. Her work had been shown earlier at the Greek Embassy in Washington in 1939, and on that occasion she presented Eleanor Roosevelt with an album of pictures from

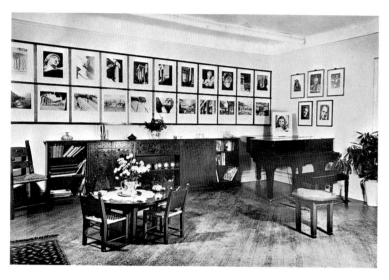

The living room of Nelly's second studio in New York, 1940s
Das Wohnzimmer in Nellys zweitem New Yorker Atelier

Greece. She joined the Hellenic Aid Campaign in support of her country after Greece was brought into the war in 1940. After the war, Nelly decorated ship interiors on behalf of the shipping magnate Aristotle Onassis. Her visual technique was transformed following a 1953 course in photojournalism with the well-known art director Alexej Brodovitch in New York, but the Greek community and visitors from Greece remained the primary subjects of her portraiture. Nelly often traveled to Europe, especially to Greece, starting in 1949.

1966–1984

After 27 years in New York, Nelly and her husband decided to return to Athens for good in 1966, when they moved to the Nea

griechischen Gemeinde von New York. So konnte Nelly 1940 in der im Zentrum Manhattans gelegenen 57. Straße ein Studio eröffnen. In dieser Zeit begann sie auch ihre Griechenlandaufnahmen auszustellen, in der New Yorker Galerie von James O'Toole, in der Columbia University oder im Baltimore Museum of Art. Einige der Bilder wurden in *Life* veröffentlicht, andere vom Metropolitan Museum of Art in New York angekauft. Bereits 1939 präsentierte sie ihre Photographien in der griechischen Botschaft in Washington; bei dieser Gelegenheit überreichte sie der Präsidentengattin, Eleanor Roosevelt, im Weißen Haus ein Album mit ihren Griechenlandbildern. Als auch Griechenland zum Kriegsschauplatz wurde, versuchte sie, ihre Heimat im Rahmen der ›Hellenic Aid Campaign‹ zu unterstützen. Nach Kriegsende entwarf sie Innendekorationen für Schiffe des Reeders Aristoteles Onassis. Nach Kursen in Photojournalismus bei dem namhaften Art Director Alexej Brodovitch 1953 in New York veränderte sich ihre Bildsprache. Doch porträtierte sie vor allem weiterhin die Mitglieder der griechischen Gemeinde oder Besucher aus Griechenland. Zahlreiche Reisen führten Nelly seit 1949 nach Europa, insbesondere nach Griechenland.

1966–1984

Nach 27jährigem New York-Aufenthalt entschlossen sich Nelly und ihr Mann 1966 zur endgültigen Rückkehr nach Athen, wo sie sich in Nea Smirni niederließen. Die Kamera nahm Nelly hinfort kaum noch zur Hand; sie beschränkte sich auf die Dunkelkammerarbeit in ihrer Wohnung. 1982 entstand die Sendereihe *100 Jahre Photographie in Griechenland* unter der Leitung von Vera Palma für das griechische Fernsehen, in der auch das Werk von Nelly exemplarisch vorgestellt wurde. Ein Jahr später führte sie Regie in der 45-minütigen Dokumentation *Nellys, a Asia Minor Photographer*.

1985–1998

1985 vermachte Nelly ihre Photographien und Kameras dem Benaki-Museum in Athen, das seither Ausstellungen ihrer Werke nicht nur in Griechenland, sondern auch in Japan, Frankreich, Spanien und den USA organisiert und betreut hat. 1987 wurde sie von der griechischen Kulturministerin Melina Mercouri für ihr Lebenswerk ausgezeichnet, 1995 und 1996 folgten weitere Ehrungen. 1989 veröffentlichte sie ihre Autobiographie in griechischer Sprache, ein Jahr später erschien eine umfangreiche Monographie über ihr Werk von Dionysos Fotopoulos. Es folgten zahlreiche Einzel- und Gruppenausstellungen sowie begleitende Publikationen in

Smirni district. Nelly rarely picked up her camera from then on, and was content with working in her own darkroom at home. Her work played an important role in the 1982 Greek television series by Vera Palma, "100 Years of Photography in Greece." A year later, Palma directed a 45-minute documentary on "Nelly's, an Asia Minor Photographer."

1985–1998

In 1985, Nelly donated her photo archives and cameras to the Benaki Museum in Athens, which has since put on shows of her work in Greece, Japan, France, Spain, and the United States. In 1987 Nelly was presented with an honorary diploma and medal for lifetime achievement by the Hellenic Centre of Photography and Greek Culture Minister Melina Mercouri. She was awarded the Order of the Phoenix by the Greek president in 1995, and the Athens Academy presented her with its Arts and Letters Award in 1996. Her autobiography was published in Greek in 1989. An exhaustive monograph on her œuvre by Dionysos Fotopoulos was followed by numerous solo and group exhibitions of her work, accompanied by publications in Greece and abroad. Six years after the death of her husband, Angelos Seraidaris, Nelly died in Athens shortly before her 100th birthday in 1998.

Nelly and her husband / Nelly und ihr Ehemann, Athens, 1985

Griechenland und dem Ausland. Sechs Jahre nach dem Tod ihres Mannes Angelos Seraidaris starb Nelly 1998 kurz vor ihrem 100. Geburtstag in Athen.

Plates / Tafeln

1
Angelos Seraidaris
unknown photographer
Dresden, early 1920s
Bromoil print, 26.2 x 21.6 cm

2
Portrait of a woman / Frauenporträt
Dresden, early 1920s
Bromoil print, 21.7 x 14 cm

3
Portrait of a young woman / Porträt
einer jungen Frau
Dresden, early 1920s
Bromoil print, 21.5 x 26 cm

4
Potrait of a woman / Frauenporträt
Dresden, early 1920s
Bromoil print, 25.6 x 21.35 cm

5
Mother and child / Mutter mit Kind
Dresden, early 1920s
Bromoil print, 38.4 x 18.6 cm

6
Portrait of a woman / Frauenporträt
Dresden, early 1920s
Bromoil print, 21.6 x 15.9 cm

7
Portrait of a young woman
Porträt einer jungen Frau
Dresden, early 1920s
Bromoil print, 21 x 16.1 cm

8
Nude / Akt
Dresden, early 1920s
Bromoil print, 21.5 x 22.3 cm

9 Nude / Akt
Dresden, early 1920s
Bromoil print, 26 x 22.5 cm

10
Dancers from Mary Wigman's School
Tänzerinnen der Schule von Mary Wigman
Dresden, early 1920s
New print

11
Dancer / Ausdruckstänzerin
Dresden, early 1920s
New print

12
Dancers from Mary Wigman's School
Tänzerinnen der Schule von Mary Wigman
Saxon Switzerland, Germany, 1923
Bromoil print, 22.6 x 19.2 cm

13
Dancer from Mary Wigman's School
Tänzerin der Schule von Mary Wigman
Saxon Switzerland, Germany, 1923
Bromoil print, 32.8 x 18.7 cm

14
Landscape / Landschaft
Germany, early 1920s
Bromoil print, 18.2 x 17.3 cm

15
Landscape / Landschaft
Germany, early 1920s
Bromoil print, 15.9 x 18.9 cm

16
Dioskouron street in the old city of Athens, with
the Acropolis in the background / Straße in der
Altstadt von Athen mit Blick auf die Akropolis
Athens, 1927–29
Bromoil print, 24 x 15.9 cm

17
The ruins of the stoa of Attalus in the area
of the ancient Agora with the Acropolis in the
background / Die Ruinen der Attalos-Stoa auf
der ehemaligen Agora mit der Akropolis
im Hintergrund
Athens, 1927–29
Bromoil print, 16.7 x 22.5 cm

18
Houses in the Anafiotika quarter on the north-
east slope of the Acropolis / Häuser im
Stadtviertel Anafiotika nordöstlich
der Akropolis
Athens, 1927–29
Bromoil print, 22.6 x 16.5 cm

19
Greek refugees from Asia Minor
Griechische Flüchtlinge aus Kleinasien
Athens, 1925–27
Bromoil print, 26.5 x 20.4 cm

20
Greek refugees from Asia Minor
Griechische Flüchtlinge aus Kleinasien
Athens, 1925–27
Bromoil print, 22 x 22.5 cm

21
The children of the Koumantaros family
Die Kinder der Familie Koumantaros
Athens, late 1920s
Bromoil print, 19.5 x 32.2 cm

22
Portrait of a woman / Frauenporträt
Athens, late 1920s
Bromoil print, 22.7 x 16.8 cm

23
Portrait of a woman / Frauenporträt
Athens, 1930s
Silver bromide print, 21.8 x 16 cm

24
Portrait of Mrs. Retsina / Porträt von Madame
Retsina
Athens, 1930s
Silver bromide print, 34.5 x 26.7 cm

25
Portrait of a boy / Porträt eines Knaben
Athens, late 1920s
Bromoil print, 21.2 x 15.6 cm

26
Riga Iliopoulou
Dresden, early 1920s
Bromoil print, 22.7 x 16.7 cm

27
Mona Paiva in Nelly's studio
Mona Paiva in Nellys Atelier
Athens, 1927
New print

28
Mona Paiva in Nelly's studio
Mona Paiva in Nellys Atelier
Athens, 1927
New print

29
The dancer Mona Paiva on the Acropolis
Die Tänzerin Mona Paiva auf der Akropolis
Athens, 1927
Bromoil print, 19.9 x 19.8 cm

30
The dancer Mona Paiva on the Acropolis
Die Tänzerin Mona Paiva auf der Akropolis
Athens, 1927
Bromoil print, 25.5 x 22.3 cm

31
The dancer Nikolska in the Propylaea
Die Tänzerin Nikolska in den Propyläen
Athens, 1929
Silver bromide print toned sepia, 21.9 x 15.9 cm

32
The dancer Nikolska in the Parthenon
Die Tänzerin Nikolska im Parthenon
Athens, 1929
Silver bromide print, 27.1 x 34.4 cm

33
The athlete Dimitris Karabatis on the Acropolis
Der Sportler Dimitris Karabatis auf der Akropolis
Athens, 1925
Bromoil print, 21 x 21.7 cm

34
Athlete on the Acropolis
Sportler auf der Akropolis
Athens, 1925
Bromoil print, 21.2 x 21.6 cm

35
Propylaea / Propyläen
Athens, late 1920s
Bromoil print, 21.8 x 26.4 cm

36
View of the Erechtheion from the Propylaea
Blick von den Propyläen auf das Erechtheion
Athens, c. 1930
Silver bromide print toned sepia, 15.9 x 21.7 cm

37
The Caryatids of the Erechtheion
Die Karyatiden des Erechtheion
Athens, c. 1930
Silver bromide print, 37.8 x 27.5 cm

38
Part of the western Parthenon frieze
Teil des westlichen des Parthenonfrieses
Athens, c. 1930
Silver bromide print, 28 x 37.8 cm

39
Olympia—the entrance to the stadium
Eingangstor zum Stadion von Olympia
Olympia, Greece, late 1920s
Bromoil print, 16.7 x 28.2 cm

40
Ancient ruins at Olympia
Ruinenfeld in Olympia
Olympia, Greece, 1927
Bromoil print, 19.8 x 27 cm

41
Head of Alexander the Great
Kopf Alexanders des Großen
Acropolis Museum, Athens, c. 1930
Bromide print toned sepia, 21.3 x 13.3 cm

42
Heracles and the lion of Nemea, metope from
the Temple of Zeus in Olympia / Herakles und

der Löwe von Nemea, Metope vom Zeustempel
in Olympia
Olympia, Greece, late 1920s
Bromide print toned sepia, 37.3 x 28.9 cm

43
Cretans / Kreter
Crete, Greece, late 1920s
Silver bromide print toned sepia, 21.8 x 29.5 cm

44
Portrait of an old man
Porträt eines alten Mannes
Greece, late 1920s
Bromoil print, 27.2 x 20.6 cm

45
Trees / Bäume
Greece, late 1920s
Bromoil print, 28.1 x 20.6 cm

46
Trees / Bäume
Greece, late 1920s
Bromoil print, 27.8 x 20.8 cm

47
Skyscraper / Wolkenkratzer
New York, c. 1950
Silver bromide print, 24.2 x 19.7 cm

48
Collage for the World Fair in New York
Collage für die Weltausstellung in New York
Athens, late 1930s
Silver bromide print, 48.9 x 28.3 cm
New Print

49
Collage for the World Fair in New York
Collage für die Weltausstellung in New York
Athens, late 1930s
Silver bromide print, 48 x 27.6 cm
New Print

50
Collage for the World Fair in New York
Collage für die Weltausstellung in New York
Athens, late 1930s
Silver bromide print, 48.7 x 28.2 cm
New Print

51
Collage for the World Fair in New York
Collage für die Weltausstellung in New York
Athens, late 1930s
Silver bromide print, 48 x 27.3 cm
New Print

52
Skyscrapers / Wolkenkratzer
New York, c. 1950

Silver bromide print, 26.2 x 26.7 cm
Double exposure / Doppelbelichtung

53
Skyscraper / Wolkenkratzer
New York, c. 1950
Silver bromide print, 34.1 x 13.7 cm

54
Skyscrapers / Wolkenkratzer
New York, c. 1950
Silver bromide print, 28 x 25.1 cm

55
Skyscrapers / Wolkenkratzers
New York, c. 1950
Silver bromide print, 20.1 x 19.5 cm

56
Building a skyscraper / Bau eines Wolkenkratzers
New York, c. 1950
Silver bromide print, 33.7 x 26.6 cm

57
Workers at rest / Arbeiter in der Pause
New York, c. 1950
Silver bromide print, 19.8 x 19.2 cm

58
From the *Easter Parade* series
Aus der Serie *Easter Parade*
New York, c. 1950
Silver bromide print, 23.4 x 17.95 cm

59
Shop window—from the *Easter Parade* series
Das Schaufenster – Aus der Serie *Easter Parade*
New York, c. 1950
Silver bromide print, 32.2 x 27 cm

60
Nelly by Hugo Erfurth
Nelly – photographiert von Hugo Erfurth
Dresden, 1923
Silver bromide print toned sepia, 21.4 x 16.3 cm

Bibliography

Ideale Körper-Schönheit, Dresden: Vitus-Verlag, 1924

Albrecht Penck, *Griechische Landschaften*, Bielefeld / Leipzig: Velhagen & Klasing, 1933

Nelly's, Oi photographies tou Mesopolemou, hrsg. von / ed. by Benaki-Museum, Athens, 1987 (mit einem Text von / with a text by Demosthenes Agraphiotis)

Nelly's Santorini 1925–1930, hrsg. von / ed. by The Archives of Santorinian Studies, Athens 1988 (mit Texten von / with texts by Yannis Tsarouchis, Nelly, Demosthenes Agraphiotis, Dimitris Tsitouras)

Nelly's Autobiography, hrsg. von / ed. by Emanuel Casdaglis, Athens: Anagramma, 1989

Dionisis Fotopoulos, *Nelly's*, hrsg. von / ed. by Cultural Institute of the Agricultural Bank of Greece, Athens 1990 (mit Texten von / with texts by Alkis Xanthakis, Eurydice Trichon-Milsani, Helen Smaragdis)

Nelly's, Le corps la lumière et la Grèce antique, hrsg. von / ed. by Centre Culturel Européen de Delphes / Ministère de la Culture Grec, Barcelona 1992 (mit Texten von / with texts by Katarina Koskina, Casa Elizalde, Pandelis Arapinis)

Nelly's, Faces of Crete, aus dem Photoarchiv des / from the Photographic Archive of Benaki-Museum, Athens

I Ellada tis Nelly's: Photographies 1921–1939, hrsg. von / ed. by Cultural Center of the Popular Bank of Cyprus, Nikosia 1993 (mit Texten von / with texts by Irene Boudouri, Fani Constantinou)

Nelly's: I palaia polis ton Athinon, Athens: Gnosi, 1996 (mit Texten von / with texts by Dimitrios Kampouroglou, Fani Constaninou)

›I Ellada me to phako tis Nelly's‹, in *Kathimirini Epta Imeres*, Athens, 30. Juni 1996 / June 30, 1996 (mit Texten von / with texts by Alexis Savvakis, Eurydice Trison-Milsani, Irene Boudouri, Maria Karavia, Bodo von Dewitz, Fani Constantinou, Alkis X. Xanthakis)

Nelly's: Body and Dance, Ausstellungskatalog / exhibition catalogue Kalamata, hrsg. von / ed. by Benaki-Museum, Athens, 1997 (mit Texten von / with texts by Vicki Marakopoulou, Klimentini Vounelaki, Irine Boudouri)

Nelly's from Athens to New York. A Retrospective Exhibition of the work of Elli Seraidari, kuratiert von / curated by Katerina Koskina, Ausstellungskatalog / exhibition catalogue, International Center of Photography, New York, hrsg. von / ed. by F. Costopoulos Foundation Benaki-Museum, Athens 1997 (mit Texten von / with texts by Katerina Koskina, Fani Constantinou, Irene Boudouri)

Nelly's, a great Greek Photographer, kuratiert von / curated by Katerina Koskina, Ausstellungskatalog / exhibition catalogue, hrsg. von / ed. by European Cultural Center of Delphi / Shizuoka Performing Arts Center, Japan, 1999